PICTURING
THE BIG SHOP
Photos of the U.S. Government
Publishing Office, 1900-1980

GPO

U.S. GOVERNMENT PUBLISHING OFFICE

732 North Capitol Street, NW, Washington, DC 20401
www.gpo.gov | Keeping America Informed | www.govinfo.gov

Library of Congress Cataloging-in-Publication Data

Names: United States. Government Publishing Office, author.
Title: Picturing the big shop : photos of the U.S. Government Publishing Office, 1900-1980.
Description: Washington, DC : U.S. Government Publishing Office, [2017]
Identifiers: LCCN 2016059195 | ISBN 9780160936241 | ISBN 0160936241
Subjects: LCSH: United States. Government Printing Office—History—Pictorial works. | United States. Government Publishing Office—History—Pictorial works. | Printing, Public—United States—History—Pictorial works. | Bookbinding—United States—History—Pictorial works.
Classification: LCC Z232.U6 U67 2017 | DDC 070.509753—dc23 | SUDOC GP 1.2:P58
LC record available at https://lccn.loc.gov/2016059195

For sale by the Superintendent of Documents, U.S. Government Publishing Office,
732 N. Capitol Street, NW, IDCC Mail Stop, Washington, DC 20401
http://bookstore.gpo.gov | toll free 888.512.1800 | DC area 202.512.1800 | fax 202.512.2250

JOINT COMMITTEE ON PRINTING

114th Congress

GREGG HARPER, Representative from Mississippi, Chairman
ROY BLUNT, Senator from Missouri, Vice Chairman
PAT ROBERTS, Senator from Kansas
JOHN BOOZMAN, Senator from Arkansas
CHARLES E. SCHUMER, Senator from New York
TOM UDALL, Senator from New Mexico
CANDICE S. MILLER, Representative from Michigan
RODNEY DAVIS, Representative from Illinois
ROBERT A. BRADY, Representative from Pennsylvania
JUAN VARGAS, Representative from California

Published Under The Authority Of
The Director of the U.S. Government Publishing Office

DAVITA VANCE-COOKS

U.S. GOVERNMENT PUBLISHING OFFICE

GEORGE D. BARNUM, Agency Historian
ANDREW M. SHERMAN, Chief of Staff

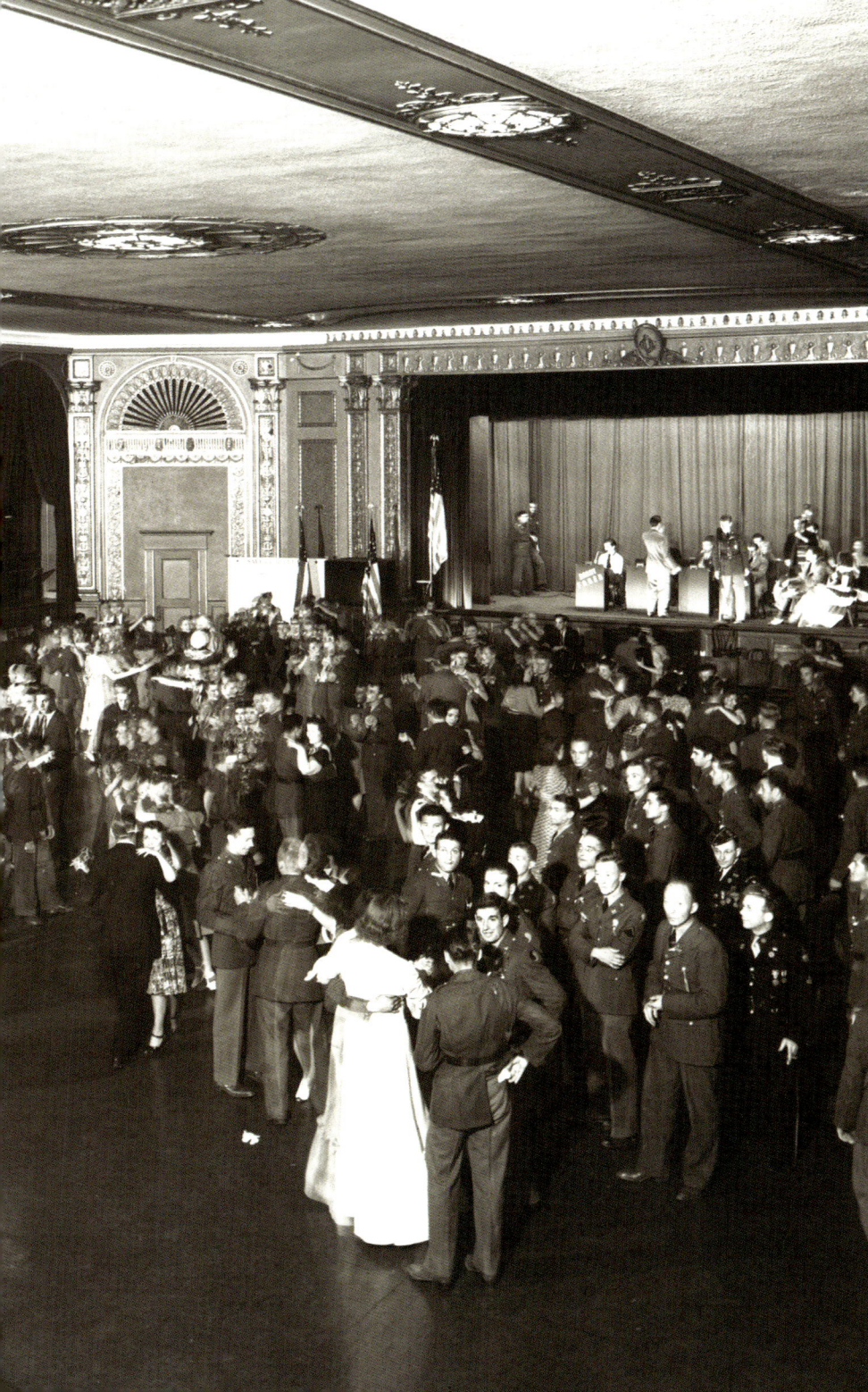

Contents

Introduction		2
Chapter 1	Buildings	8
Chapter 2	Printing	38
Chapter 3	Binding	94
Chapter 4	Support and Administration	126
Chapter 5	Superintendent of Documents	198
Chapter 6	Life of GPO	216

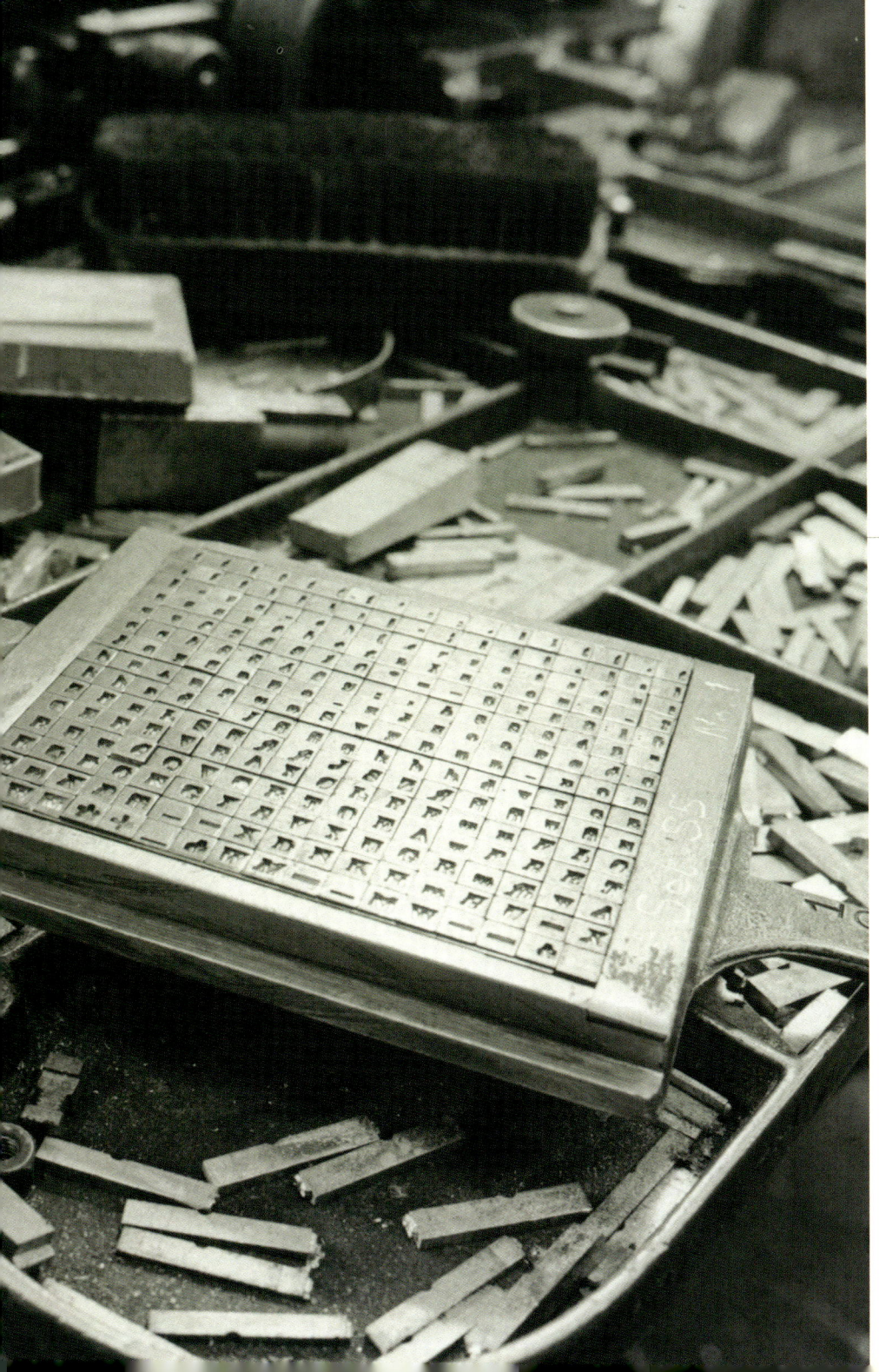

Foreword

In 2011, GPO's official sesquicentennial history *Keeping America Informed* was published, and in 2016 a revised edition was issued. In these books, GPO published selections from its historical photograph collection, which contains approximately 10,000 items and dates back to the 19th century. Graphically illustrating GPO's technological evolution over a century and a half, this collection contains a number of unusual and in many cases striking images in black and white and sepia, many of them reminiscent of the work of Margaret Bourke-White and other industrial photographers of the 20th century.

So positive was the response to the photographs in *Keeping America Informed* that we decided to assemble a representative collection of approximately 200 of the best photographs. We offer them here in this new contribution to GPO's historical record. Selected and arranged by GPO Historian George Barnum, they show the working life of this agency across the generations, leaving one with a greater appreciation of just how GPO went about fulfilling its mission to support the printing and information product requirements of Congress, Federal agencies, and the public, while impressing upon the viewer a sense not only of each photograph's subject, but of the artistry that went into the making of the photographs themselves.

GPO's history is the product of the combined efforts of the men and women who have worked here, laboring expertly and professionally, as well as quietly and behind the scenes, to carry out the important work of producing the publications and other documents that fuel the operations of our Government and keep America informed. This volume of photographs is a tribute to their efforts, and to the personnel and technologies that preceded the work we continue to carry out today.

DAVITA VANCE-COOKS
Director
U.S. Government Publishing Office

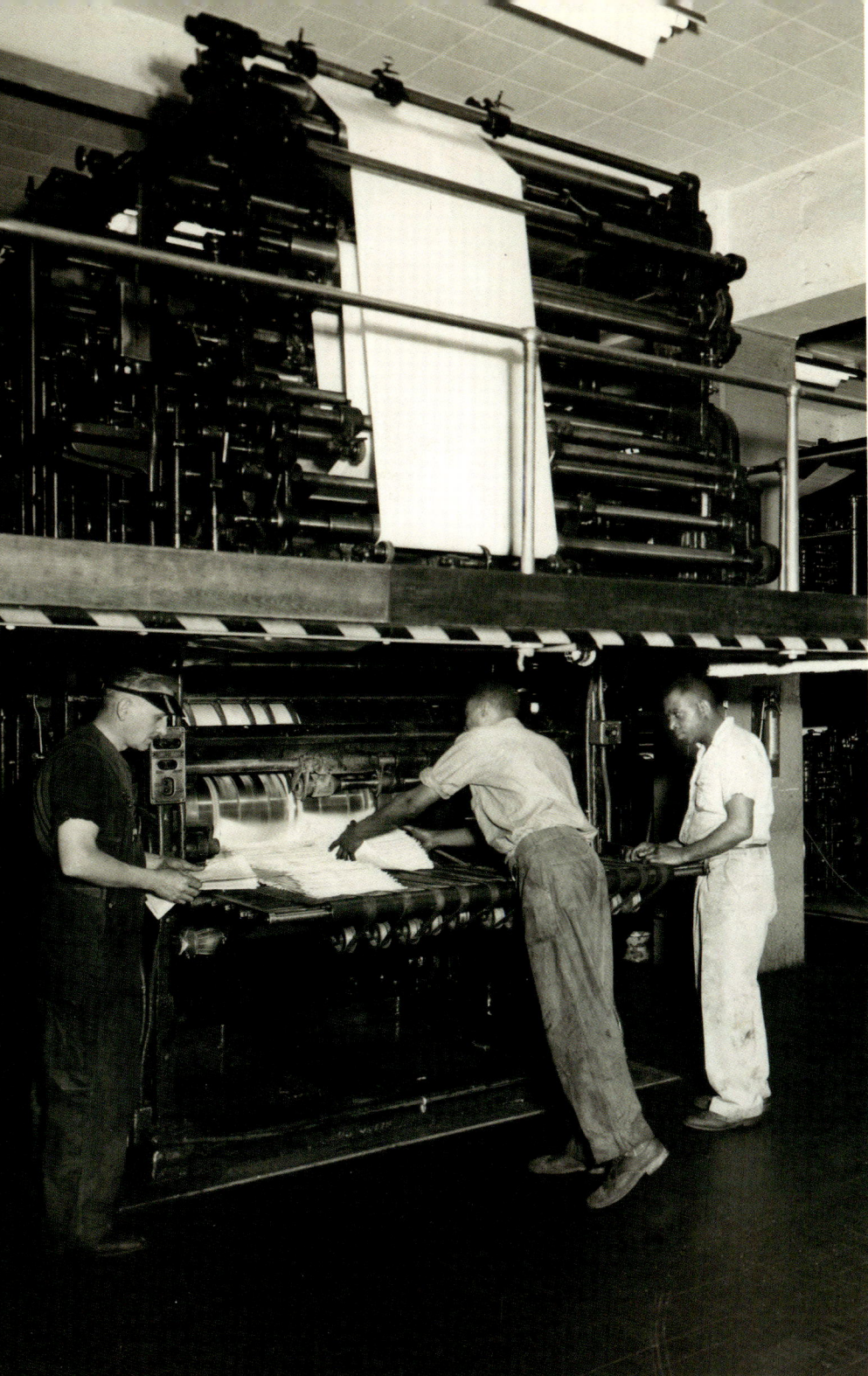

Introduction

Organizations choose many ways to depict and document their activities. Advertising, public relations campaigns, sponsorship, and corporate histories all present a view through the eye of an author. Oral histories capture the recollections of individuals and relate them to the whole organization. Government agencies, especially in the United States, often document their work in their publications and their online presence.

The Government Publishing Office has been documenting itself in a variety of forms for most of its history. The first published history of the agency appeared in the 1880s, and illustrated "tours" of "The Big Shop" were a regular feature in both the trade press and general circulation newspapers from the 1870s onward. Just as the agency itself was born of the Industrial Revolution, one of its preferred methods for recording its history has been the art form of the industrial age, photography.

From the turn of the 20th century until World War II over 10,000 photographs of GPO people, places, events, and machines were taken by professional contractor photographers in Washington, newspaper photographers, and, starting in the 1930s, GPO's own staff photographers. Almost no corner of GPO remains unrecorded. The development of printing and binding technology unfolds in image after image of presses, typesetters, folders, and ruling machines. Rarely are machines pictured in isolation: GPO workers are shown with the machines; their work is visible. Alongside images of printing and binding work are other aspects of everyday life at GPO: the buildings themselves, the neighborhood surrounding them, the many supporting jobs that undergirded the vast printed output, and the people, working and relaxing.

The agency marked its 150th anniversary in 2011 by publishing a new official history *Keeping America Informed*. The GPO photograph collection was the heart and soul of that book. Many of the images in the book (which first appeared in June, 2011, and then in a revised edition in 2016) had never been published before. As a further celebration of the anniversary, about 50 photos were selected to be enlarged, framed, and hung in the hallways on the 8th floor of the main buildings in Washington. The "history hallway" was an immediate hit with GPO employees and visitors alike, and new photos were added in 2012, 2014, and 2015, bringing the total to over 100. That selection is what forms the basis of this book.

Making a selection like this presents manifold curatorial challenges. The photos often depict tasks that haven't been in current use for over 50 years and accurate descriptions are sometimes challenging. In the case of a set of some of the most beautifully photographed images in the whole collection, it proved to be shockingly easy to unwittingly make a selection that told a story about an important and positive aspect of GPO life in the early 20th century, the Apprentice School, which simultaneously depicted a chapter of GPO's history of which no one is proud, racial segregation. Photographs are so much a part of our everyday experience that it can be easy to overlook the multiple of levels on which we see and interpret them.

This selection shows many cross-sectional views of life at GPO, with a concentration on the middle years of the 20th century, the era of GPO as the largest printing and binding concern on earth. There are cross-sections of the workforce: men and women, black and white, laborers and skilled craftspeople and managers. There are cross-sections of the work we do: not only printing and bookbinding, but platemaking and chemistry, librarianship and accounting, delivery and maintenance. There are cross sections of

technology: from the first or second generation of presses to be powered by electricity to the digital presses of today, from the GPO stable to digital dissemination.

These photos also display much about the art of industrial photography. Many of the photos are striking, especially the ones shot by the commercial firms: Harris & Ewing, Tenschert, C.O. Buckingham, and Rideout. Although they often depict highly inartistic settings, many of which were probably fairly gloomy in reality, there is balanced and clear composition in the shots that shows clearly the activity and vitality of so busy a factory.

After World War II GPO's photographic work declined, and the images that were collected become a blur of groups of employees shaking hands with GPO officials. In more recent days, with the advent of digital photography and an influx of new technology in the plant, there has been a minor renaissance, and some striking color images have found their way into this selection as well.

GPO's photographs record the ways in which thousands of people and a panoply of technology have worked together in these buildings. The GPO of today is a different place from the GPO of most of the photographs, and the agency changes continually. The photos are a tribute to all the people they depict and to many others who worked with them. It is an organizing principle of our agency history program that we can look to the challenges of our future more confidently if we understand and affirm our past. This GPO "family album" is a tribute to the dedicated men and women who, since an early March day in 1861, have worked here on this corner of North Capitol Street in the District of Columbia, and in smaller field offices across the Nation, making Government information available to all, *Keeping America Informed*.

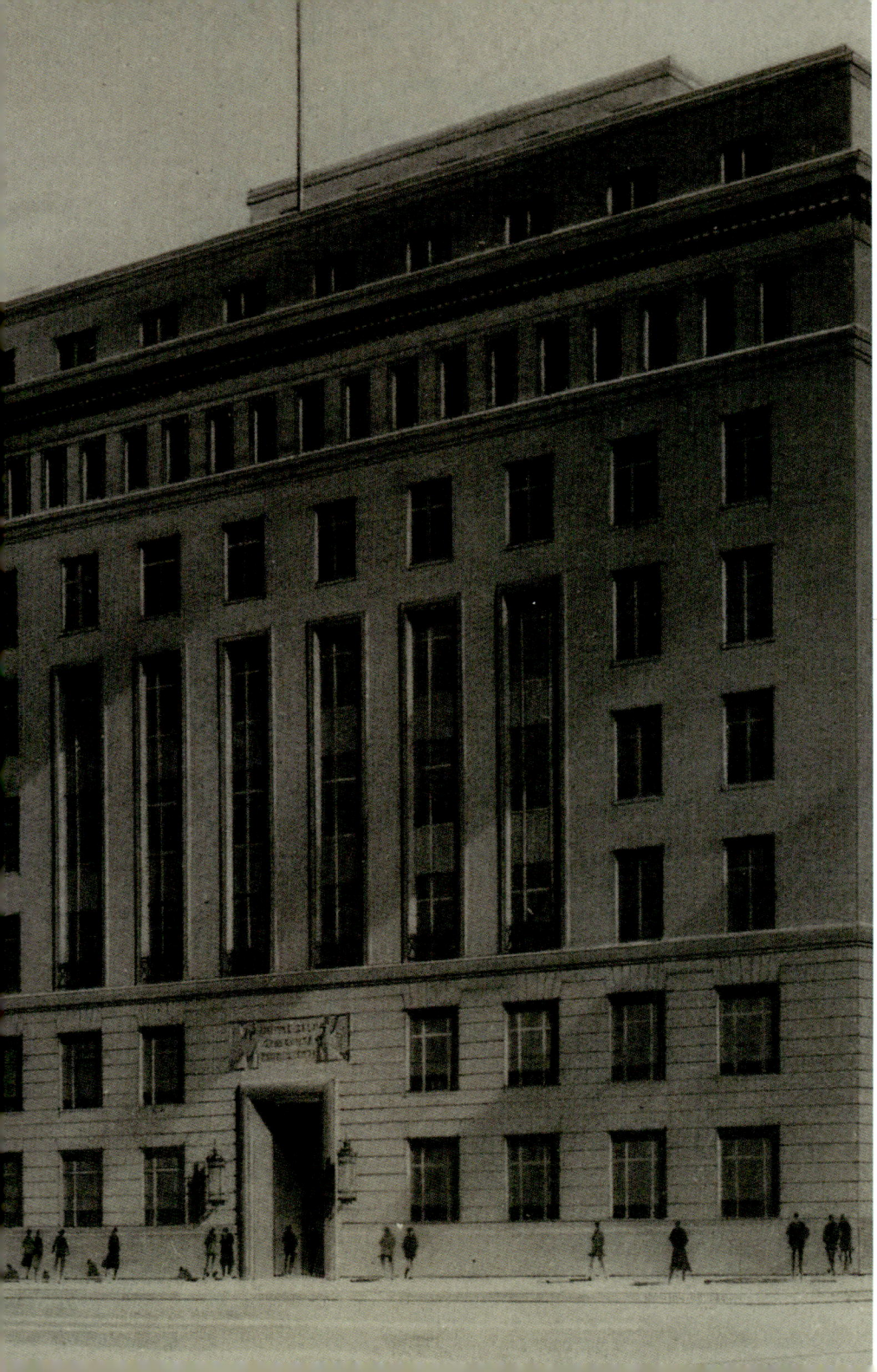

CHAPTER 1

GPO's Buildings
"From this place words may fly abroad…"

One of GPO's most distinctive attributes is that it has occupied the same location in northwest Washington, DC, through a succession of structures, for its entire history. It has inhabited the same four principal buildings that it occupies today for half that time.

Within a few years of taking over the structure built in 1856 by Cornelius Wendell, GPO began expanding its footprint on the corner of North Capitol and H Streets. Over the last three decades of the 19th century additions and annexes to that building filled much of the half square (block). In 1899 Congress acquired property on the G Street corner and began construction of Building 1, completed in 1903.

Nearly 20 years later, in 1921, the roof of Building 1 was raised to add an 8th floor. In 1928 an 8 story extension was built at the west end of Building 1, labeled Building 2.

GPO's steady growth continued and after an energetic effort from the Public Printer plans were approved in the late 1930s to replace the rabbit warren of structures on the H Street side with the new Building 3, opened in 1940. Across North Capitol Street a large Art Deco warehouse was completed in 1938. With that, GPO's total working floorspace in the central facility came to 33 acres.

Beginning with the opening of Building 1, the GPO buildings have had a distinctive architectural presence. Although they were planned as industrial buildings, their appearance in the context of neighboring houses, commercial structures, and Government buildings is on the one hand commanding (due to their size) and at the same time not overwhelming. Visitors over many decades reported surprise that "those big red buildings" were, in fact, a large working factory inside. And in the neighborhood's recent history, architects have taken cues from the massing, materials, and details of the façade of Building 1 and the rear elevations of Buildings 2 and 3 in designing neighboring commercial buildings.

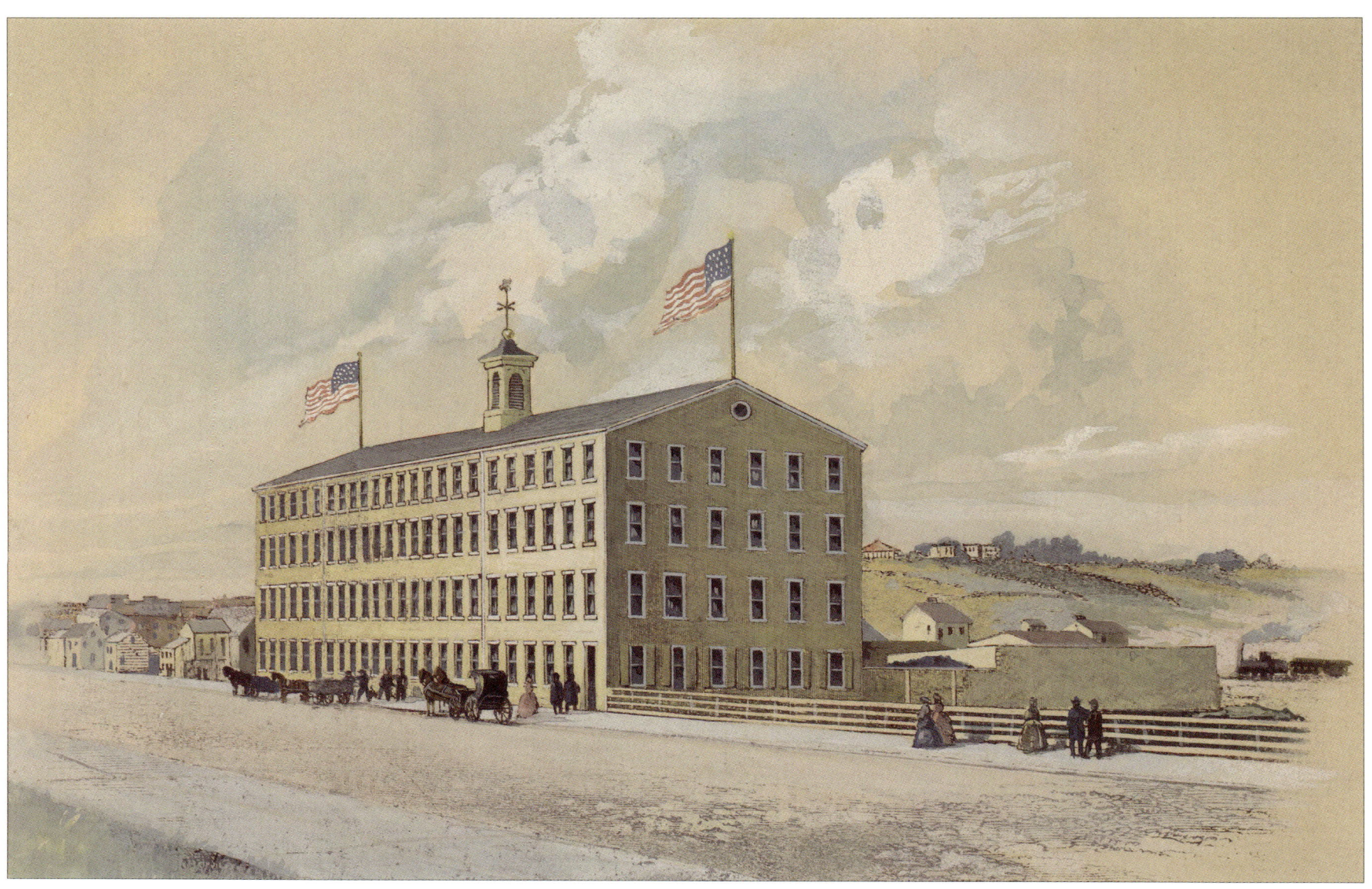

Cornelius Wendell built this building in 1856 when he was elected printer to the House of Representatives. Congress purchased it following the signing of Joint Resolution 25 (36th Congress), which directed the establishment of GPO on March 4, 1861. Wendell was paid $350,000 for the building and its equipment. It faced H Street NW, part way down the block between North Capitol Street and 1st Street NW. The area was sparsely developed, and was known as "Swampoodle" because nearby Tiber Creek regularly overflowed, making the surrounding land swampy.

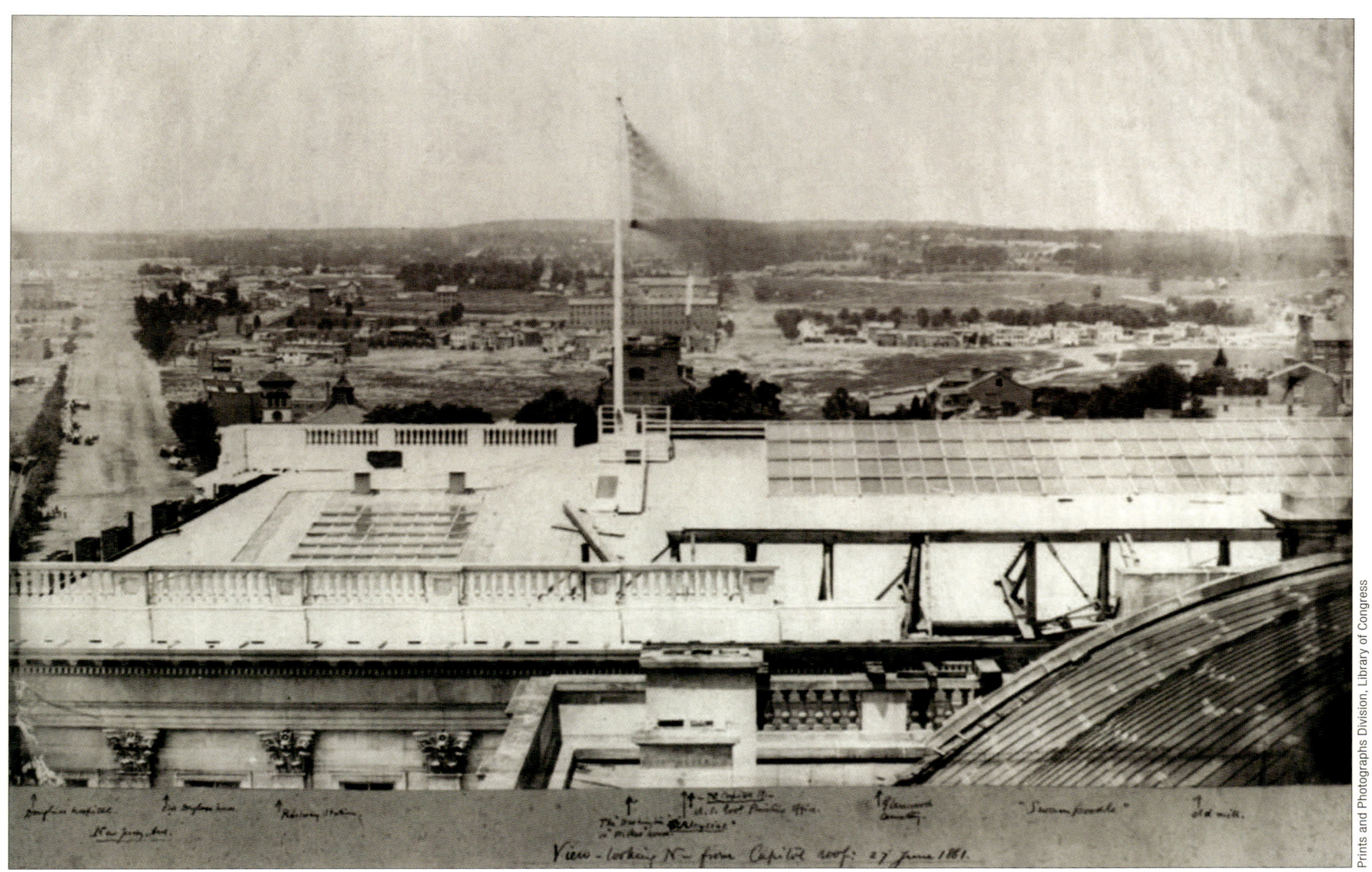

This 1861 photograph from the Library of Congress looks north, up North Capitol Street, from the roof of the Senate side of the Capitol. At the center of the photo (behind the flagstaff in the middle distance), the smokestack and the bulk of the Wendell building are visible. Beyond, the Romanesque arches of the windows of St. Aloysius Church are visible. The photo shows how much of this section of northwest Washington was still completely undeveloped, and gives an idea of the extent of the cluster of ragtag houses and shanties that formed Swampoodle (across North Capitol Street between G Street and H Street NE).

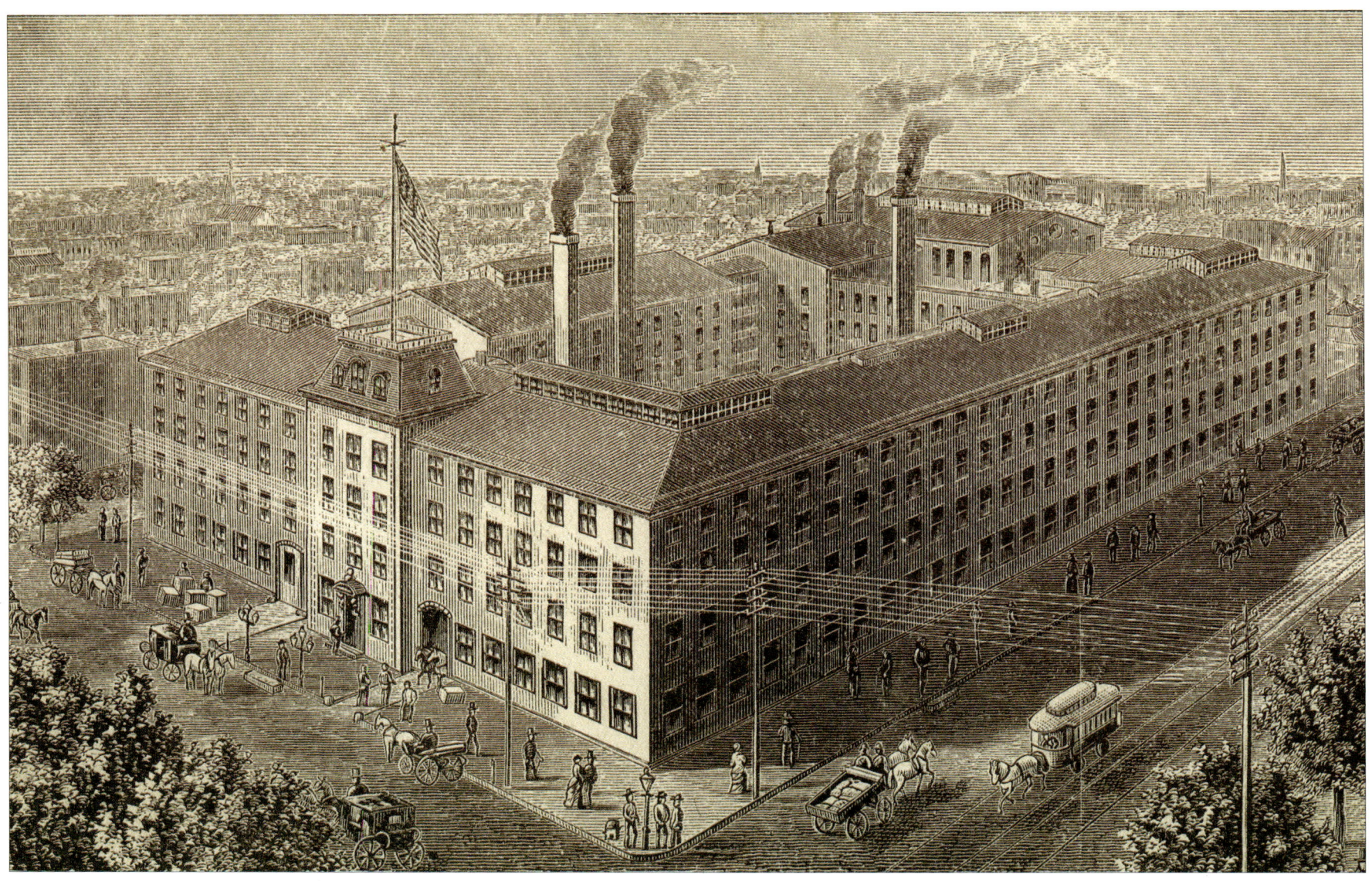

The first recorded expansion of the Wendell building was in 1865, and more additions followed steadily. By 1881, the complex covered most of the half square between H Street and Jackson Alley and most of the depth of the present-day buildings. By this time the Wendell structure was subsumed, and the entrance to the building shifted to North Capitol Street.

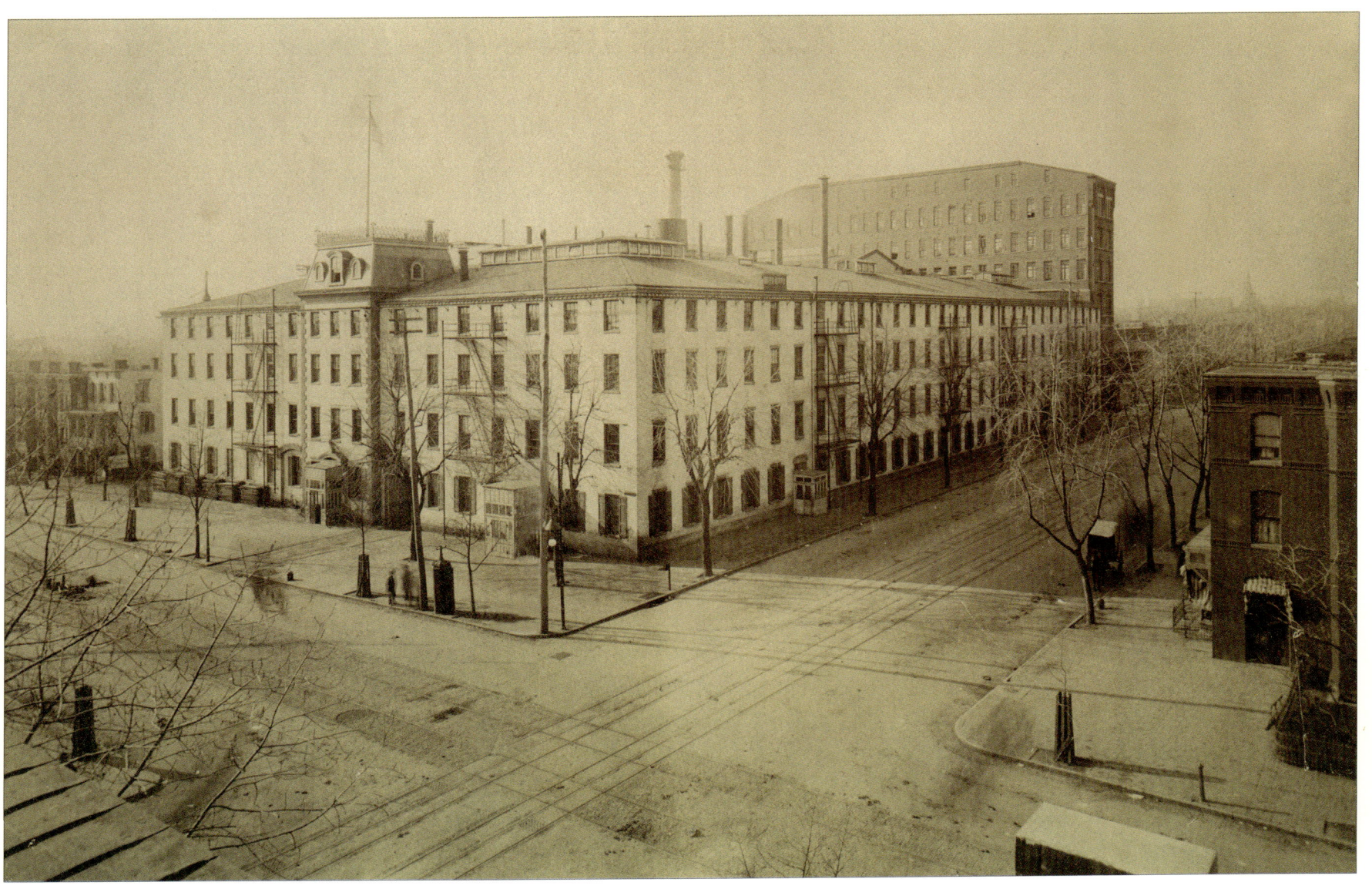

GPO continued to grow. By 1900 the inner courtyard had been built in, and in 1896 an annex had been built across the rear, eight stories tall, but very narrow. The photo shows that the neighborhood had become a residential district of modest row houses and small businesses.

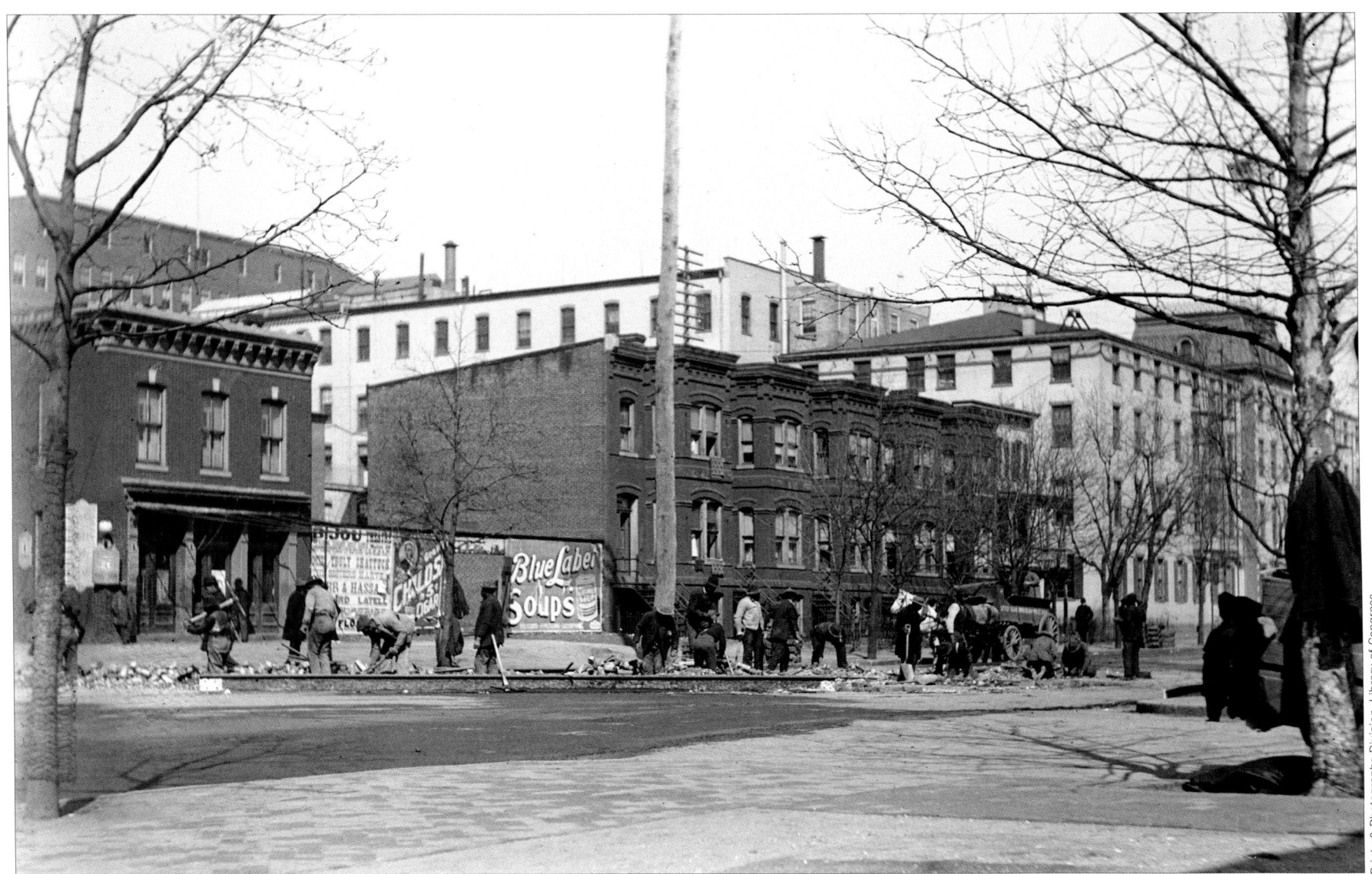

This 1897 photo from the Library of Congress was taken from the corner of G Street NE and North Capitol Street. The GPO complex is visible behind a row of houses that would be demolished in 1899 to make way for the new GPO Building 1. Workers in the foreground are laying track for the North Capitol Street streetcar line, which ran to the Soldier's Home, north of Michigan Avenue.

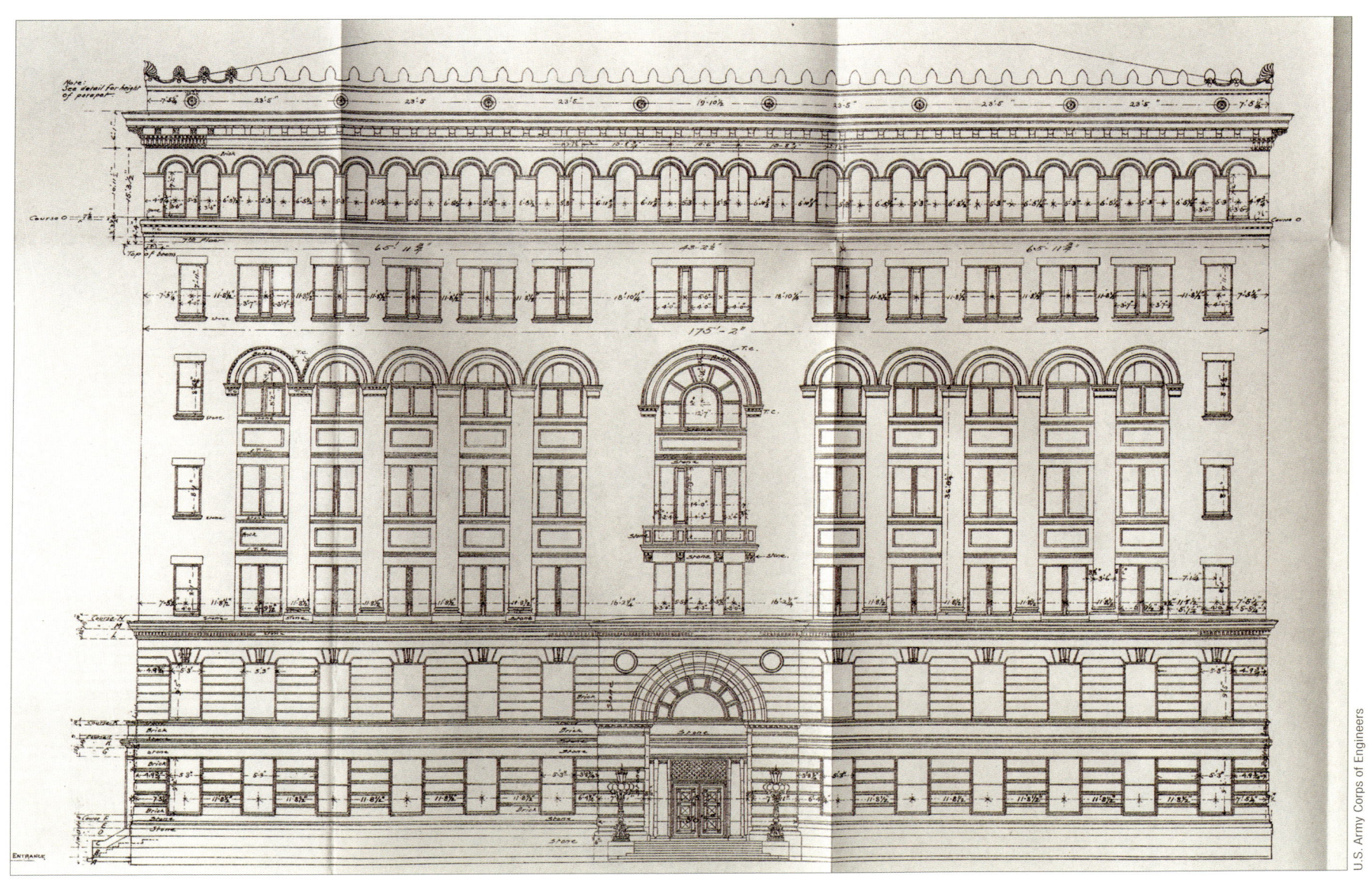

Congress authorized a new extension for GPO in 1898. Designed by James G. Hill and built under the direction of the Army Corps of Engineers, the building that became known as Building 1 was finished in 1903 and fully occupied in 1904. This elevation shows the approved design for the North Capitol Street façade.

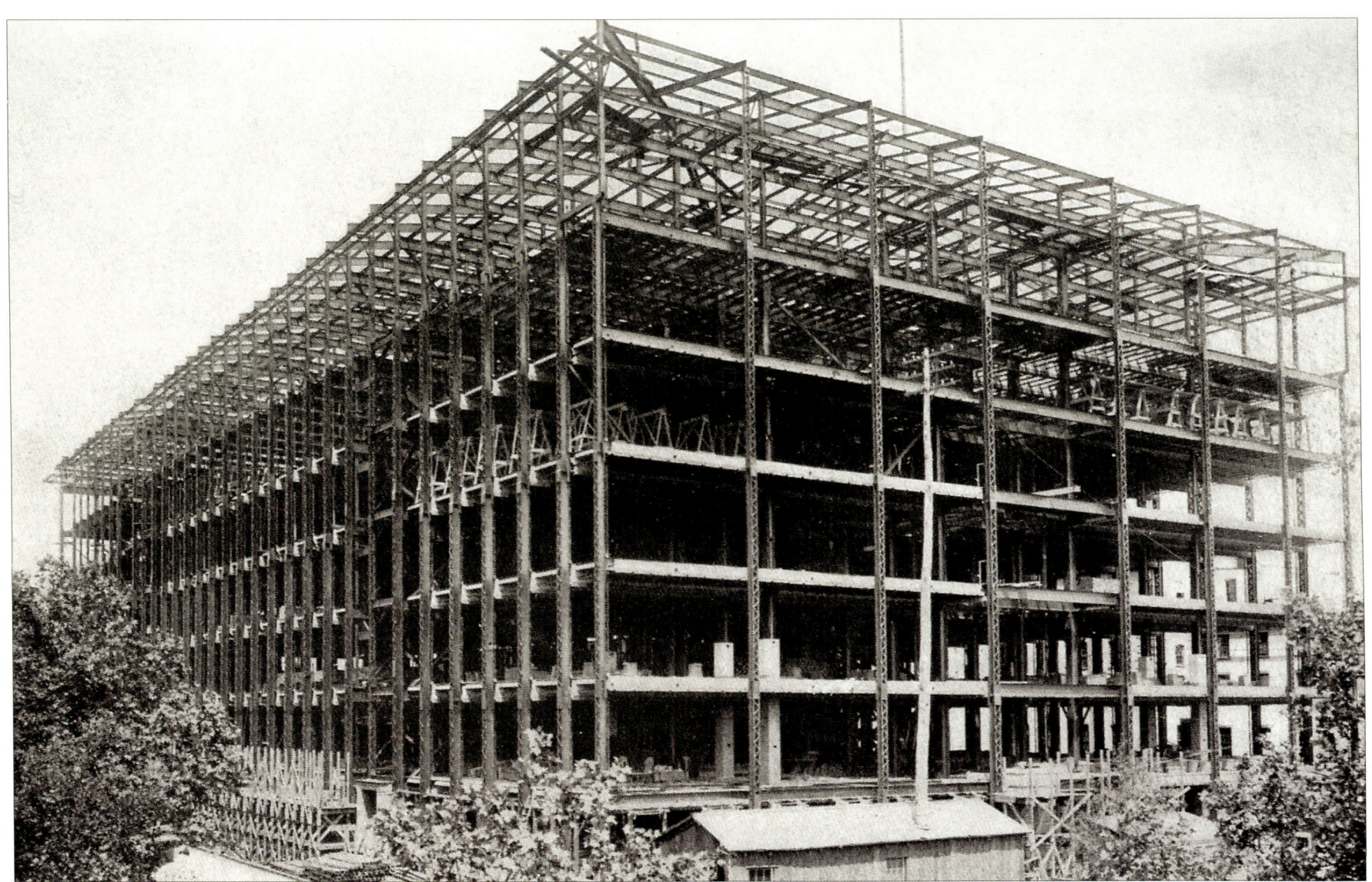

Building 1 was built to be fireproof, with a steel and masonry superstructure, finished with brick and terra-cotta on the exterior and brick and ceramic-faced brick inside.

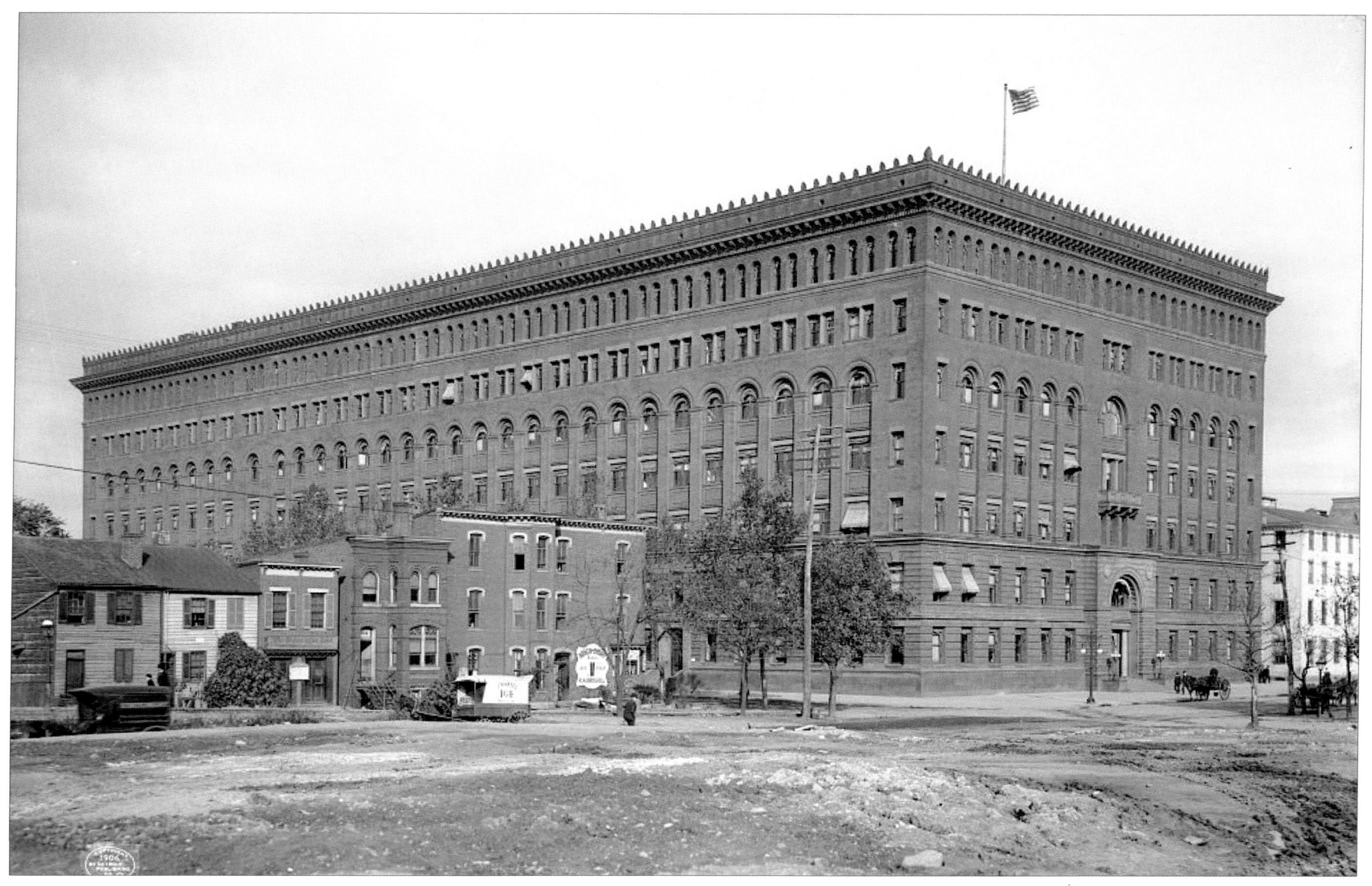

When Building 1 opened in 1903, it comprised 7 floors and basement, at the corner of North Capitol and G Streets NW. The floor space was over 377,000 square feet, about 10½ acres.

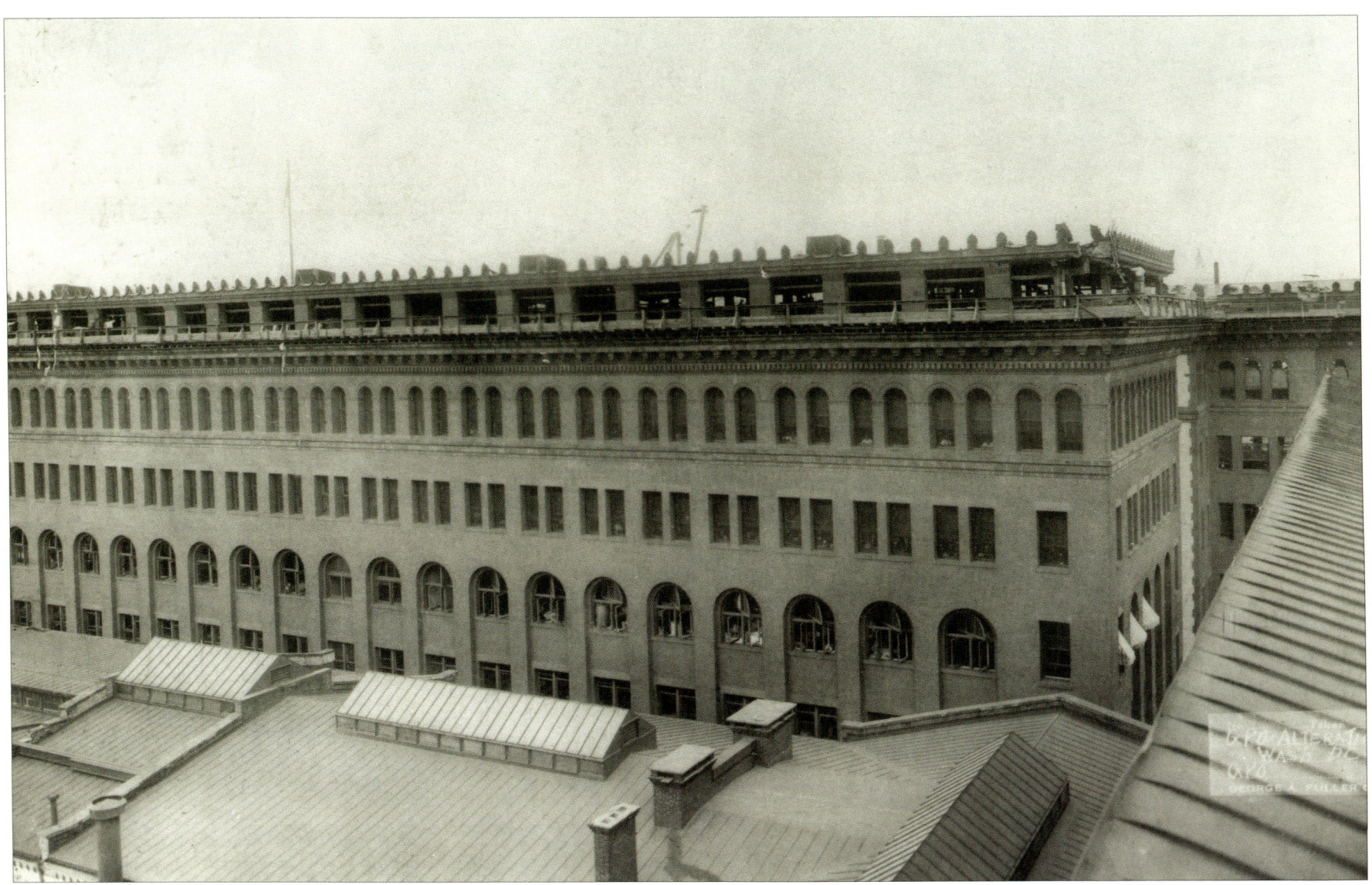

GPO's growth continued throughout most of its first 100 years. When George H. Carter became Public Printer in 1921, he directed an operating surplus to the conversion of the leaking and unusable attic story of Building 1 to a full 8th floor.

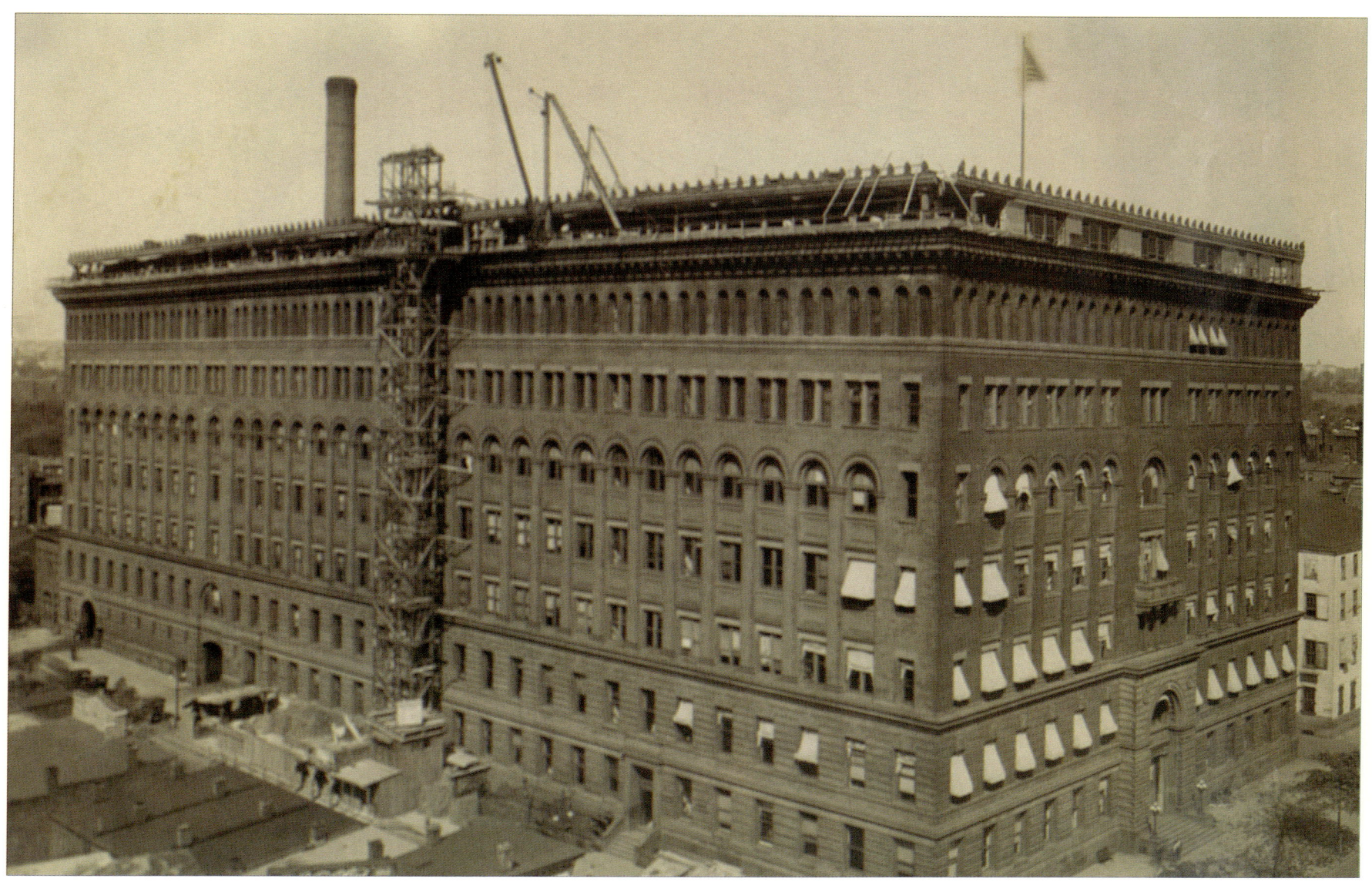
When the 8th floor was complete, it provided space for the cafeteria, Harding Hall, a bowling alley, a photoengraving plant, and storage.

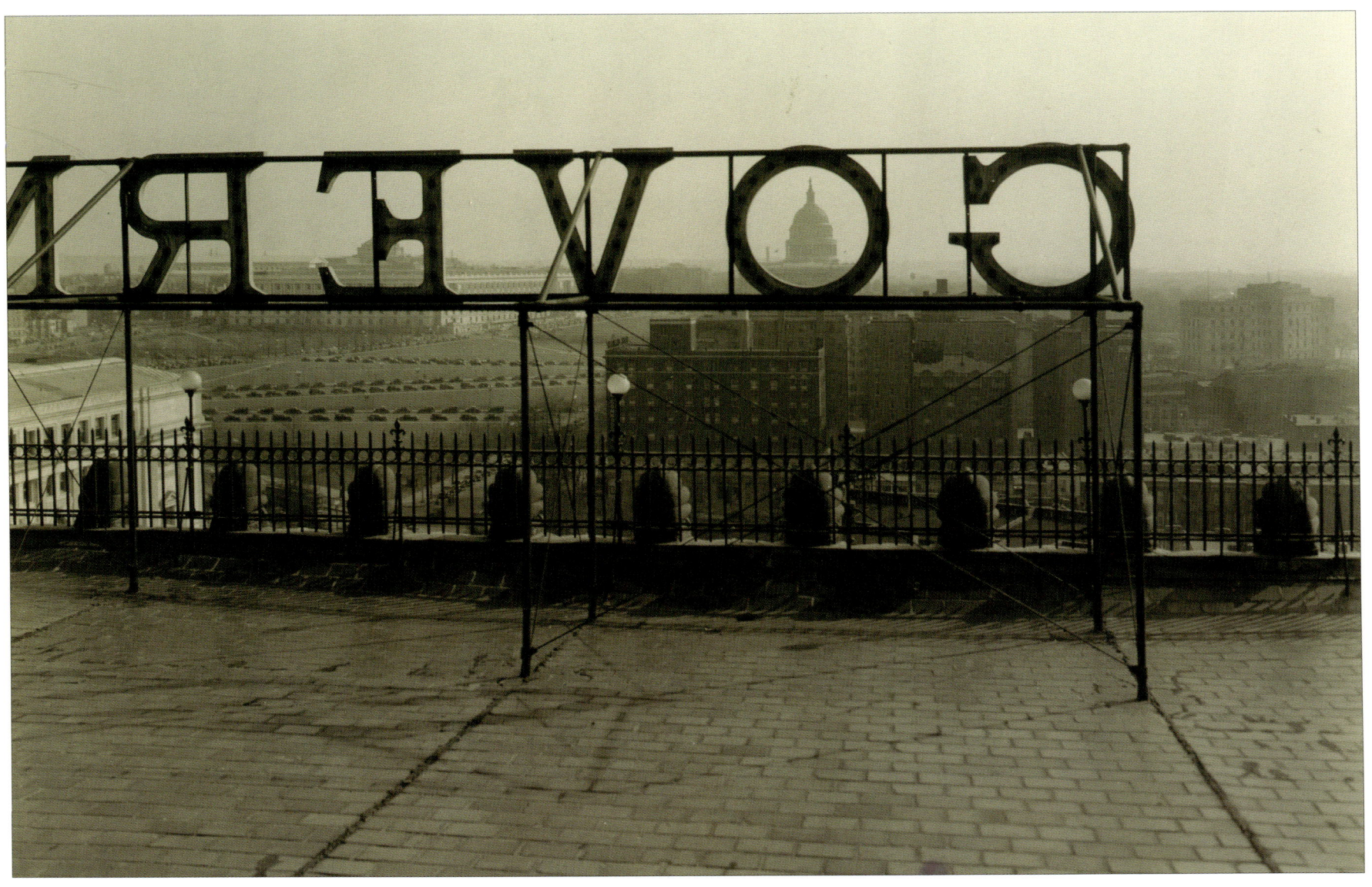
Another of the features of the 1922 renovation was a roof terrace where employees could relax or eat lunch, behind the agency's electric sign.

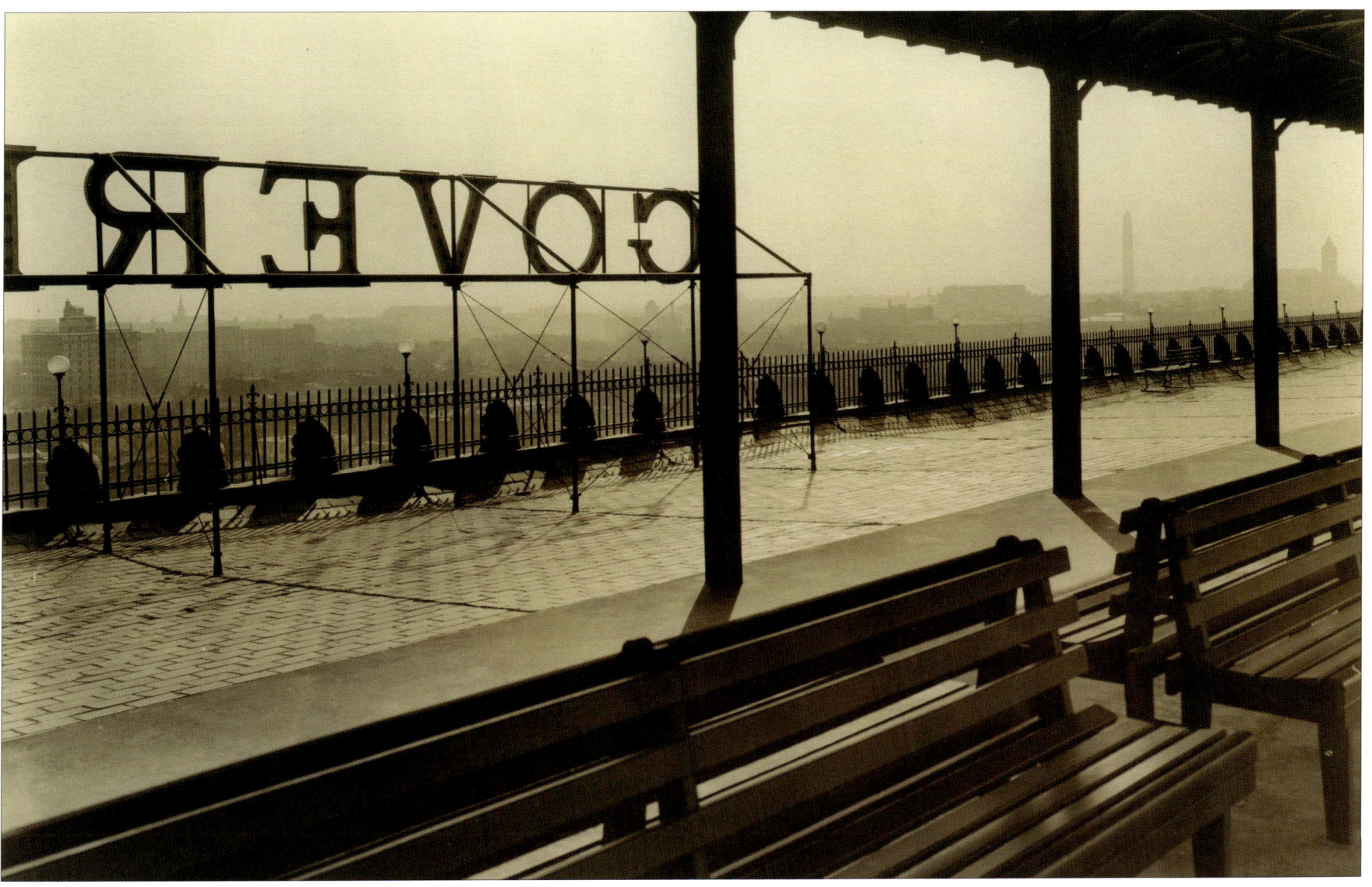

Public Printer Carter said, "A broad stairway leads to the roof where a permanent canopy has been constructed for the additional comfort of employees, who can there enjoy the fresh air and the finest view of Washington and the surrounding country that is to be had anywhere in the city."

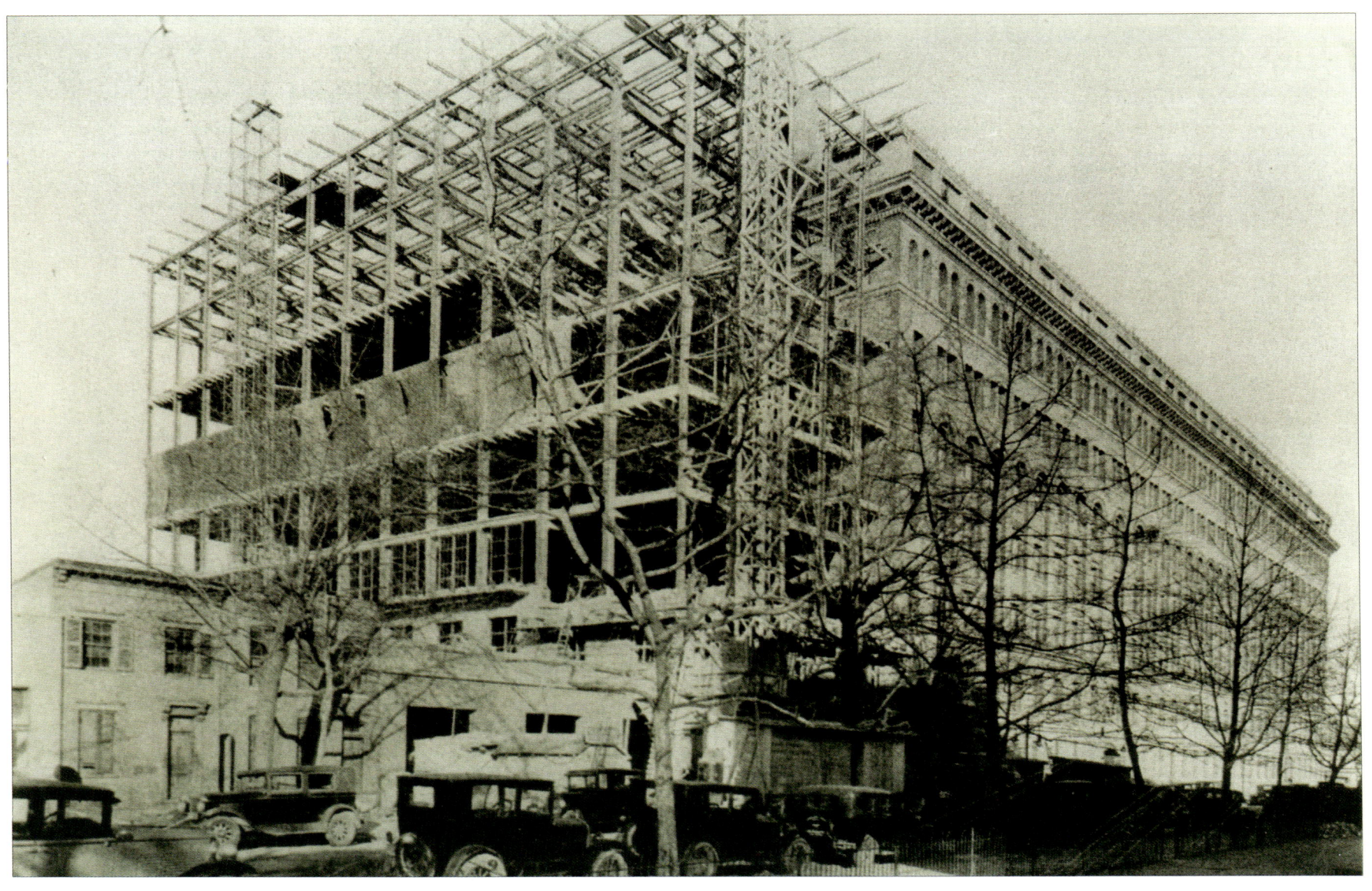

In 1926, Public Printer Carter persuaded Congress to authorize an extension to Building 1, at the rear of the building between G Street and Jackson Alley, known as Building 2.

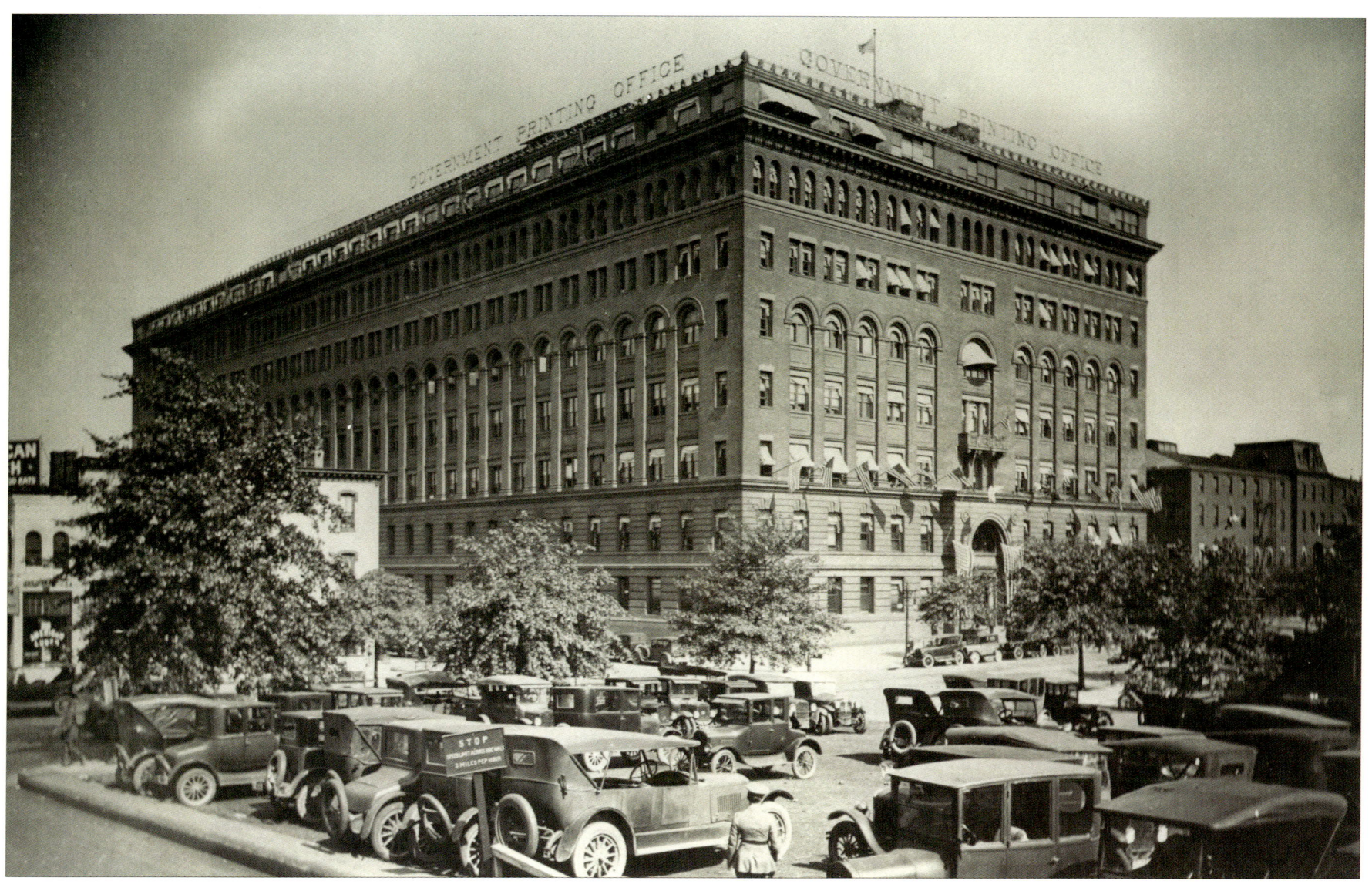

Building 2 is the same height as Building 1 and when finished was hard to detect as a different structure.

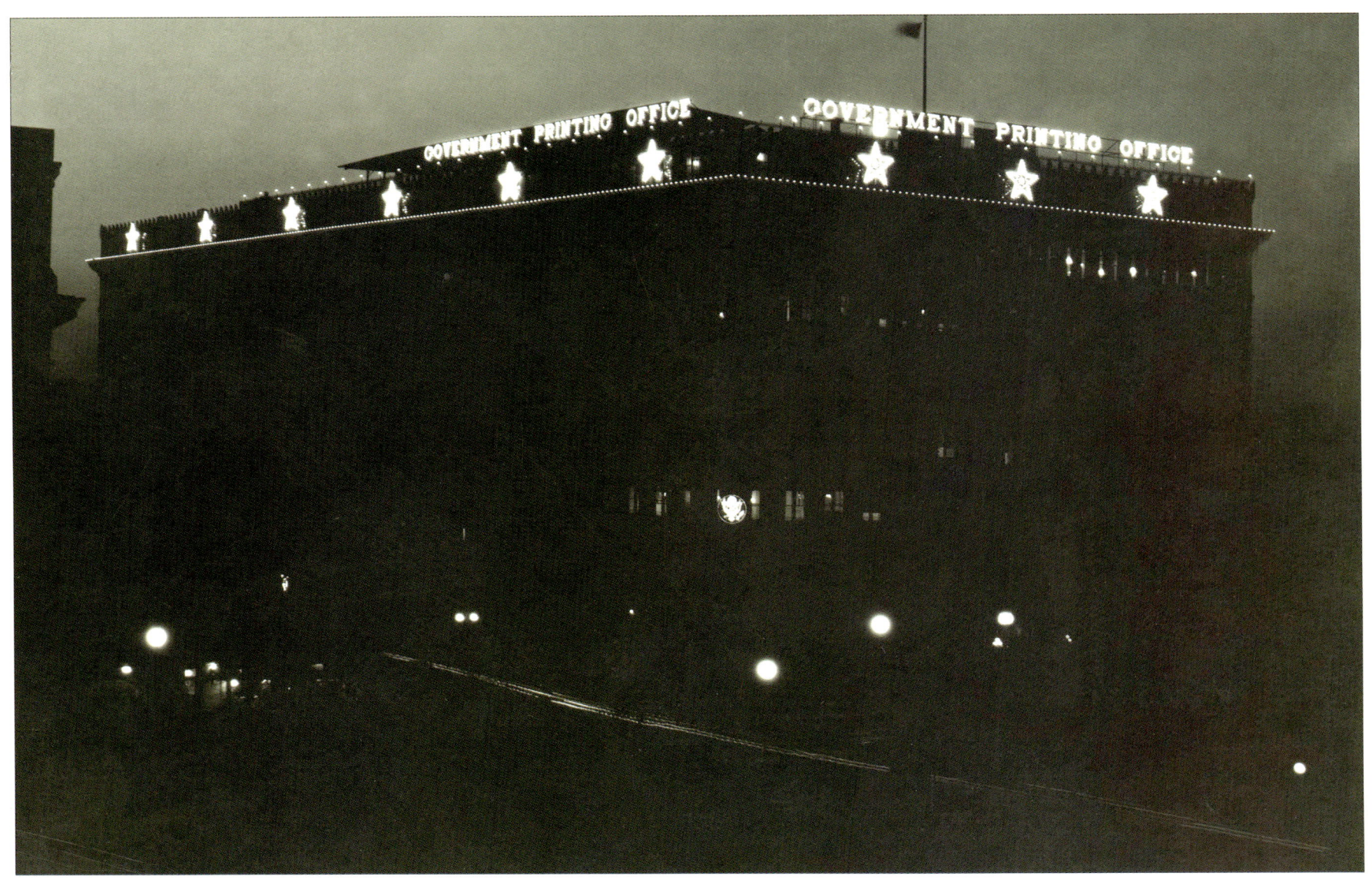

This night view shows Building 1 lit in celebration of Inauguration Day for President Coolidge, March 1925.

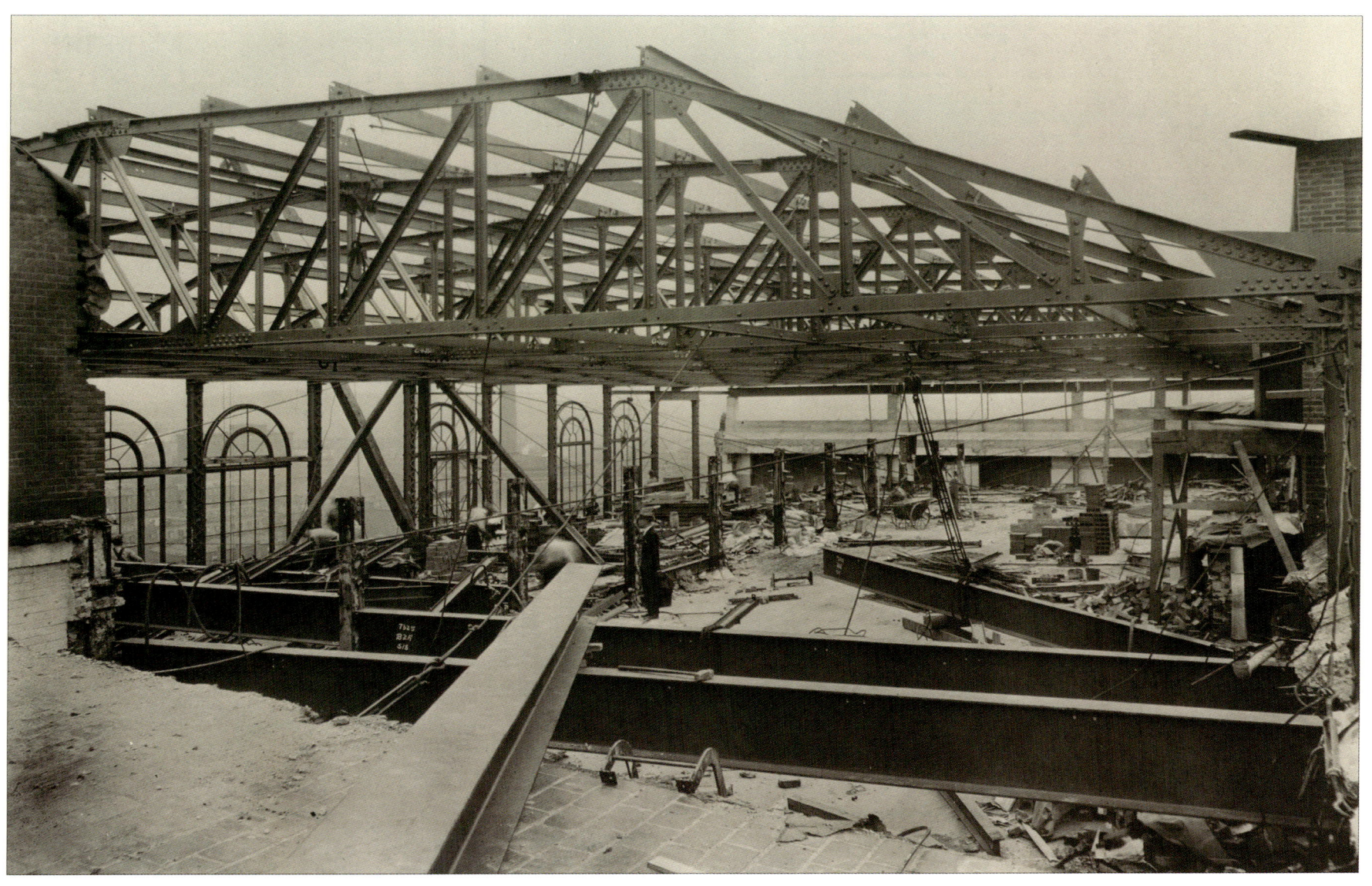
In 1929, an enlargement of Harding Hall was authorized. The roof was raised, a balcony was added, and the new hall seated 1,800. It was dedicated in May 1930.

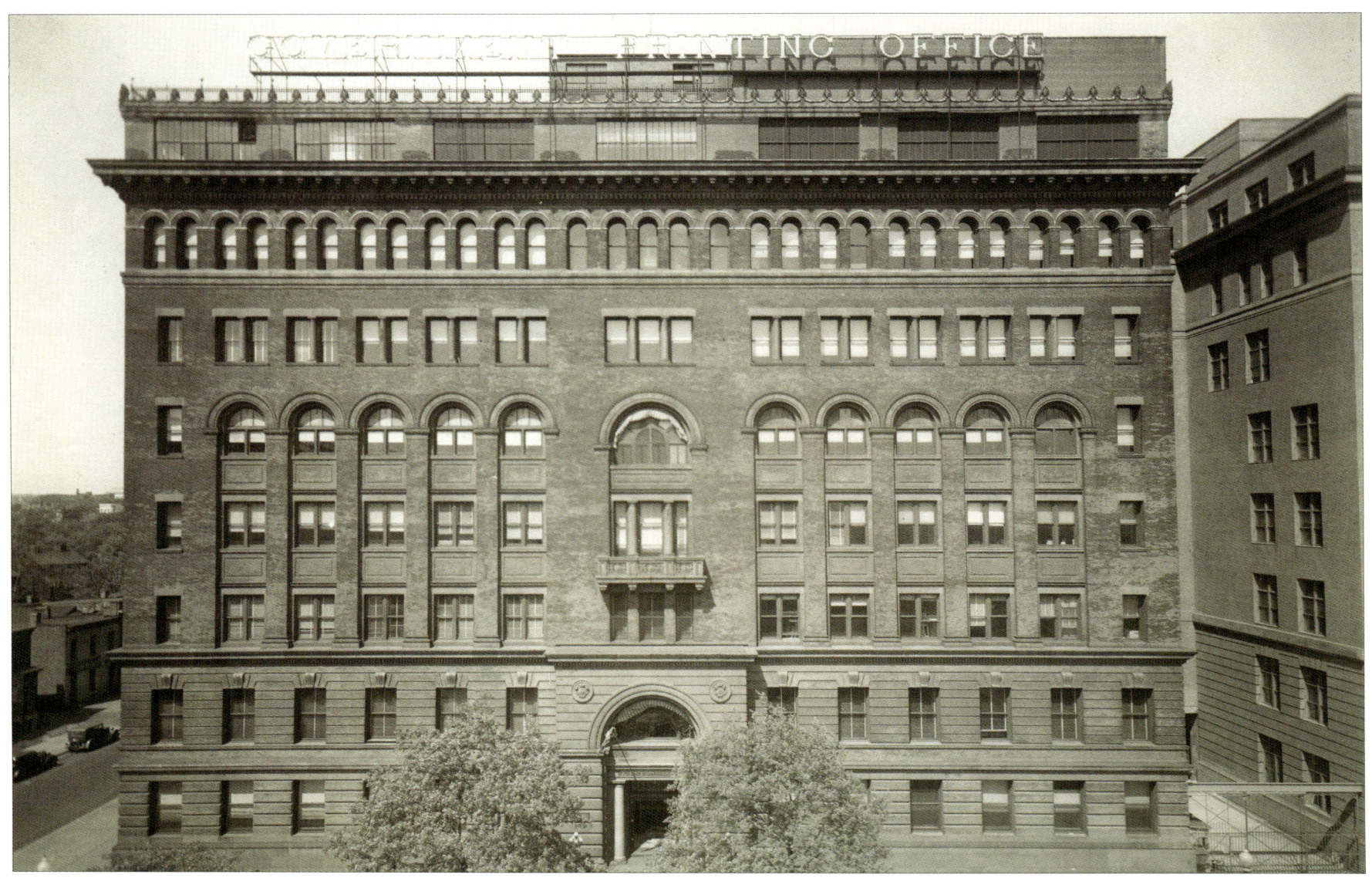

The North Capitol Street front of Building 1, with the raised roof of Harding Hall visible upper right, circa 1940. The electric sign proclaimed GPO's location from the 1920s until 1960.

In 1935, Public Printer A. E. Giegengack won approval for a new eight story building to replace the old building on the H Street side, and for a new warehouse across North Capitol Street at the corner of G Place. Building 4, the warehouse, opened first, in 1938, on this site. Most of old Swampoodle had been swept away 20 years earlier in the construction of Union Station (to the east) and the main Post Office (to the south). Building 4 replaced another jumble of 19th century structures.

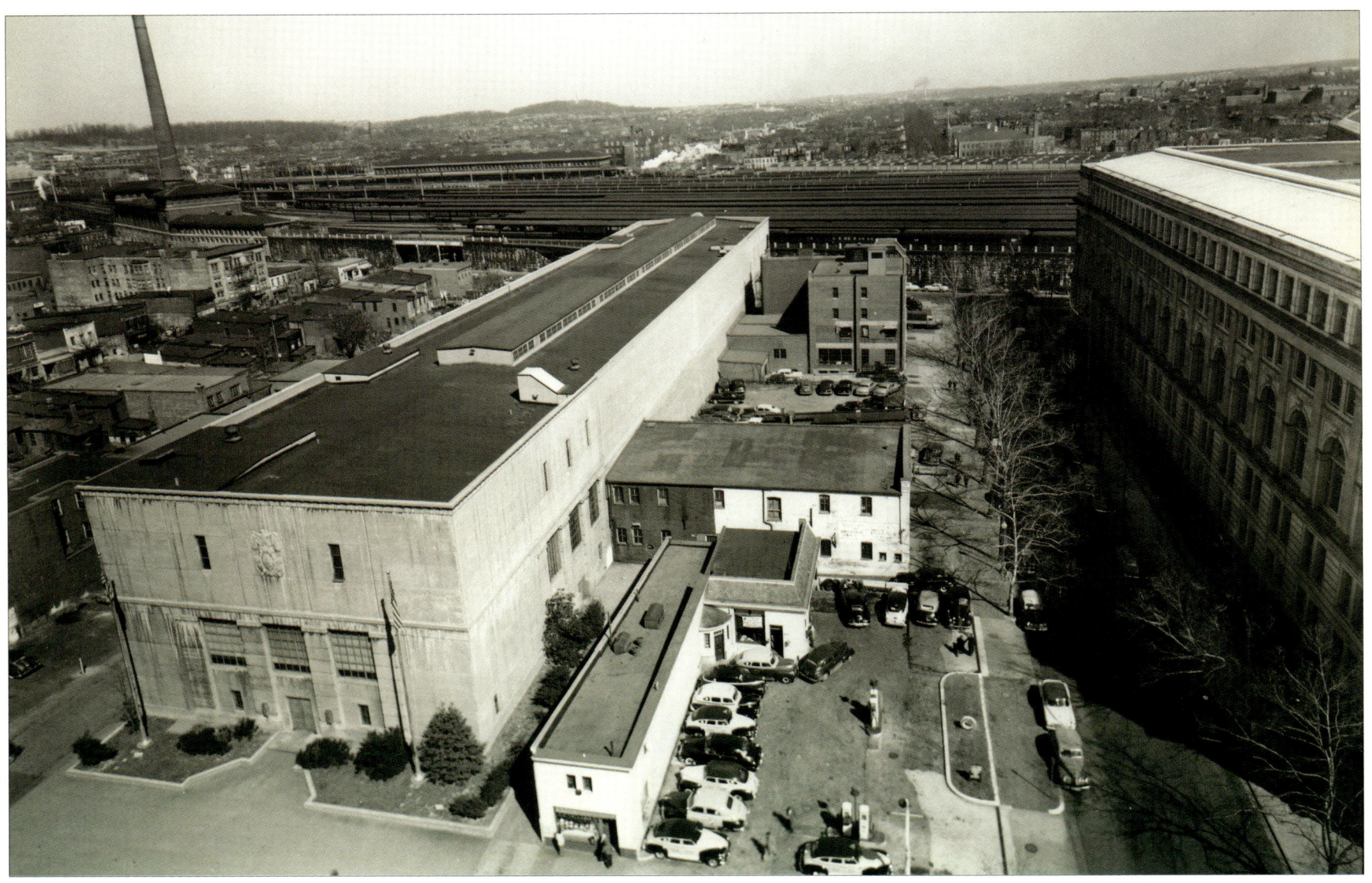

Building 4 runs the depth of the block between North Capitol Street and 1st Street NE. A dedicated railway siding was approved by Congress, built over 1st Street, connecting the warehouse to Union Station for the delivery of materials, particularly paper, and the shipment of stock.

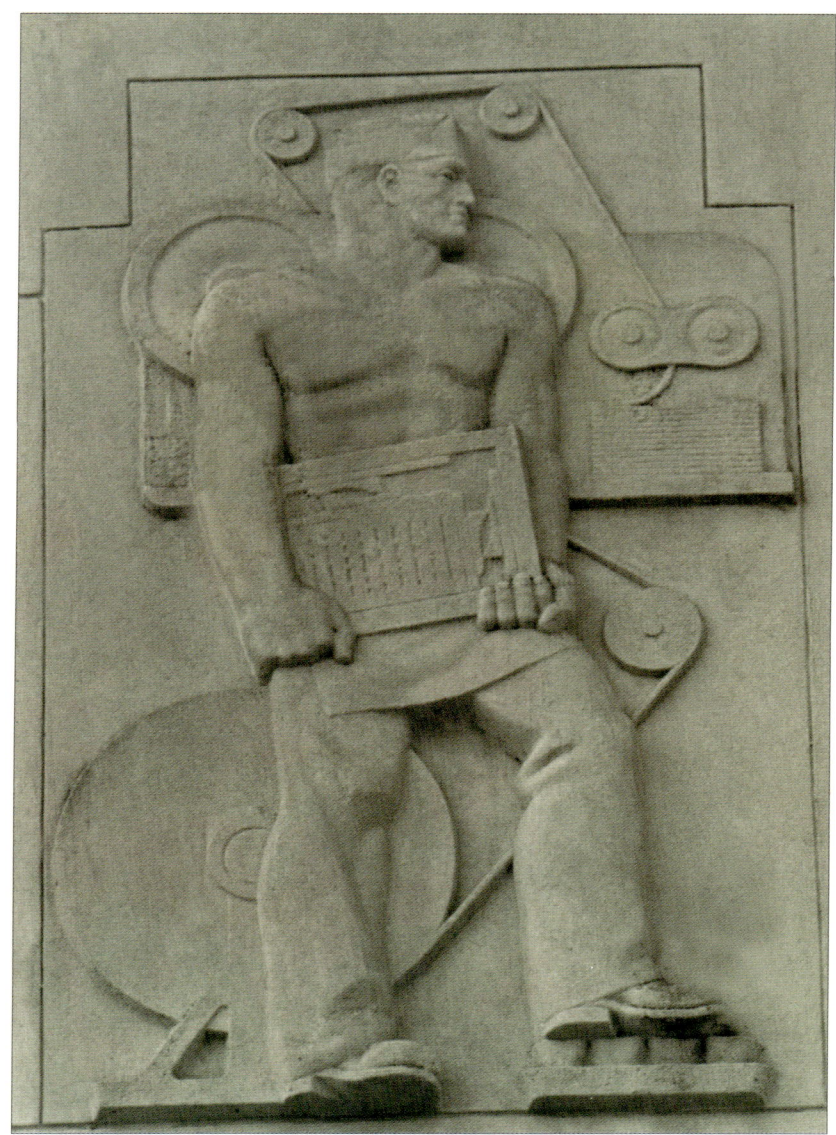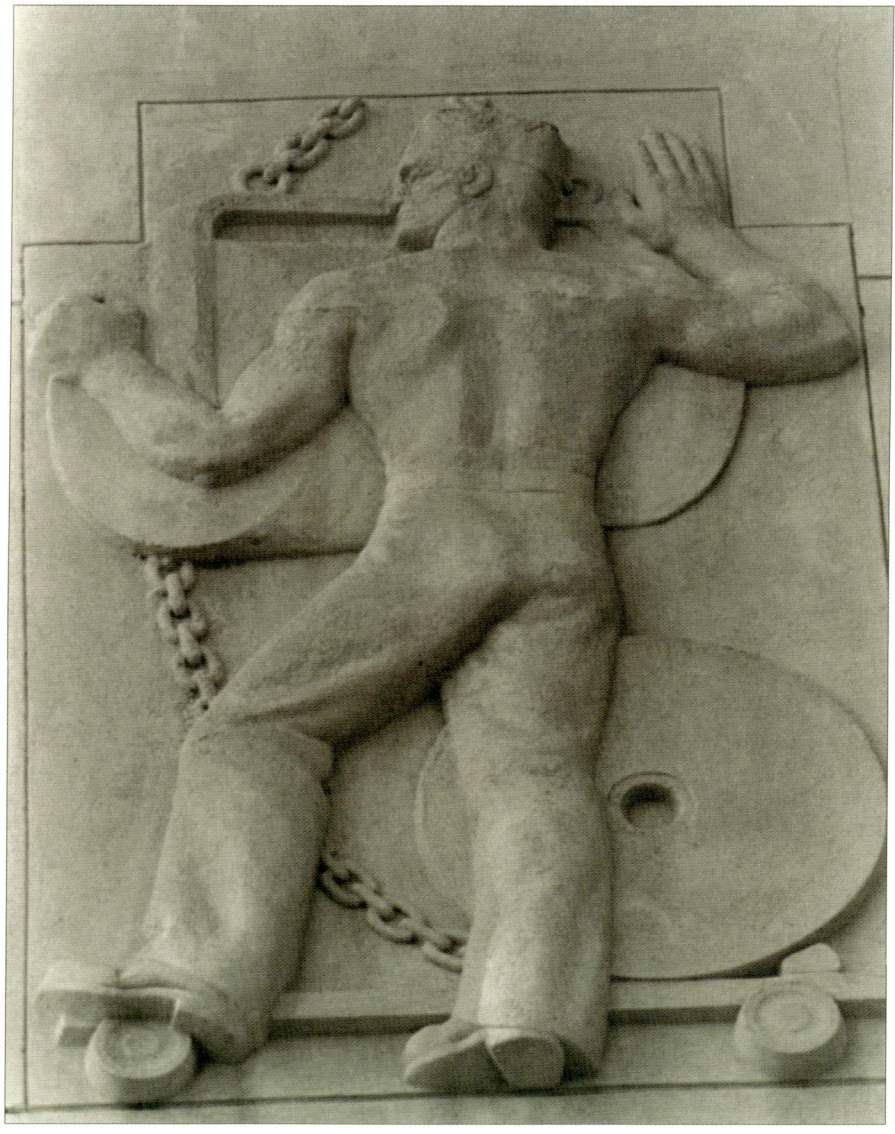

Building 4 is one of comparatively few Art Deco buildings in Washington. Its 9 foot tall bas relief sculptures on the G Place side and over the entrance were carved by Elliot Mens and Armin A. Scheler.

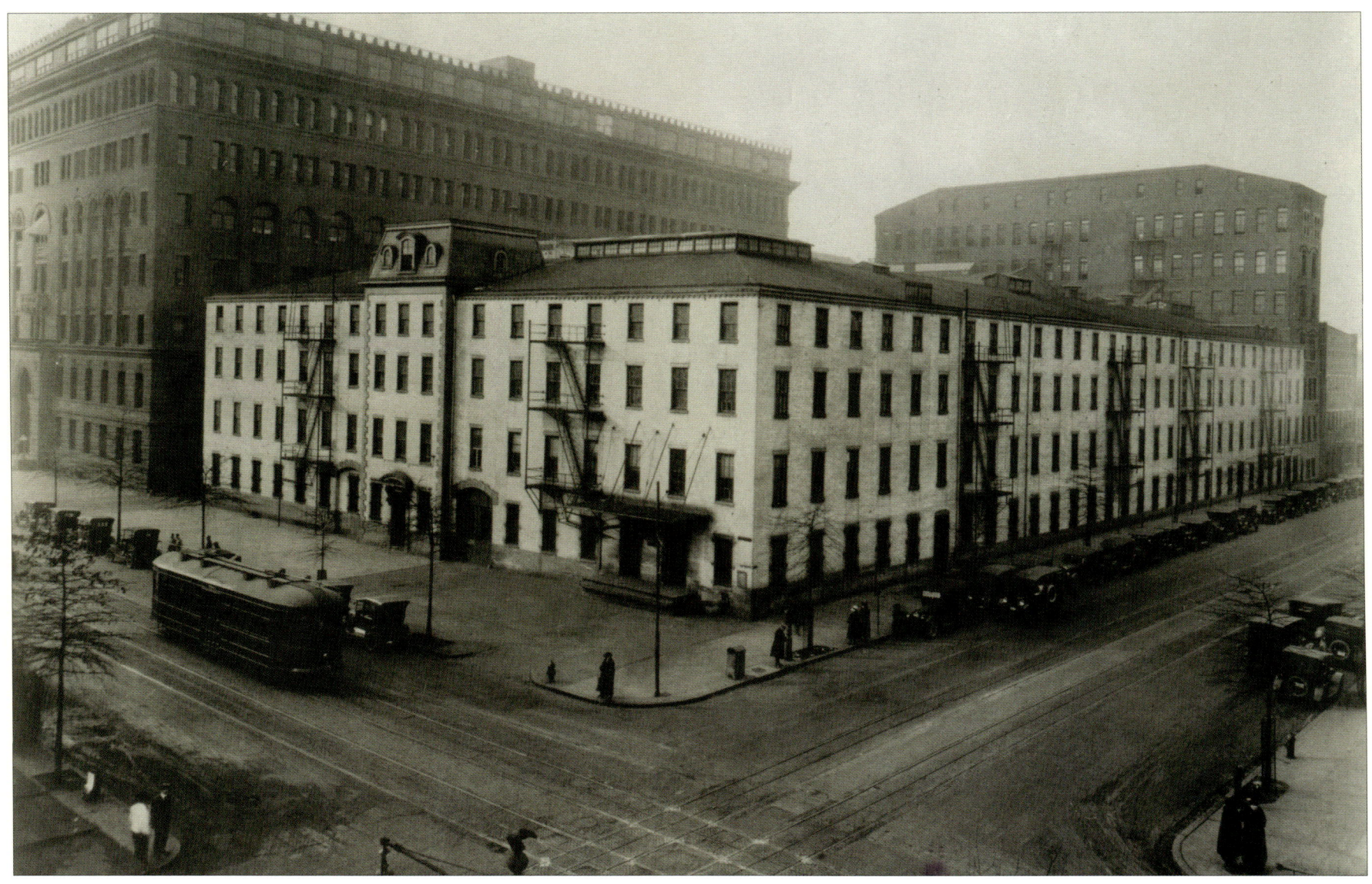

The collection of buildings on the H Street NW corner that began with the Wendell Building was finally razed in 1938.

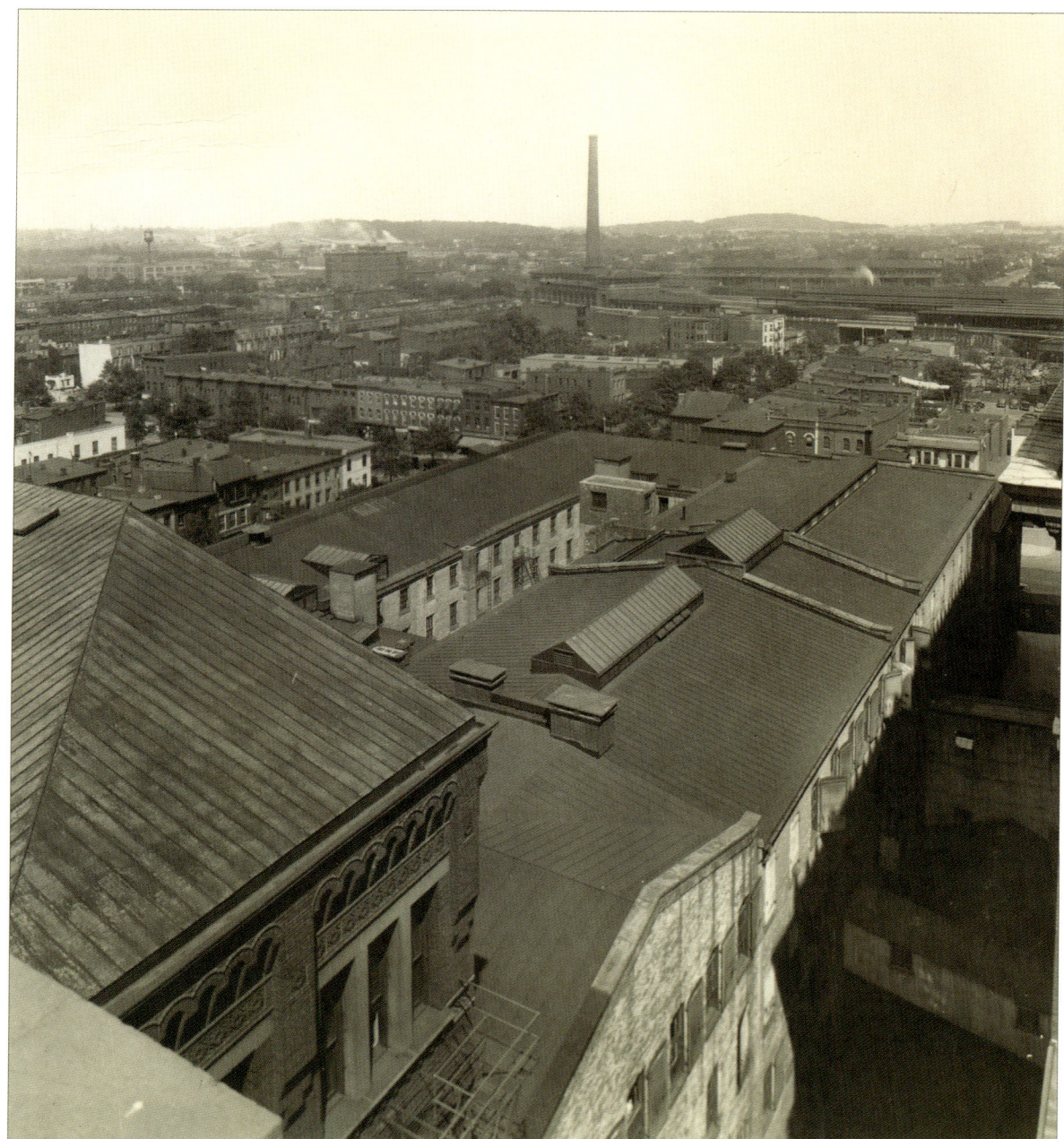

This view from the roof of Building 2 looks over the rooftops of the old building complex, with the tall narrow annex at left. Swampoodle is more densely residential, and the city has grown up all around. The tracks of Union Station are visible in the middle distance.

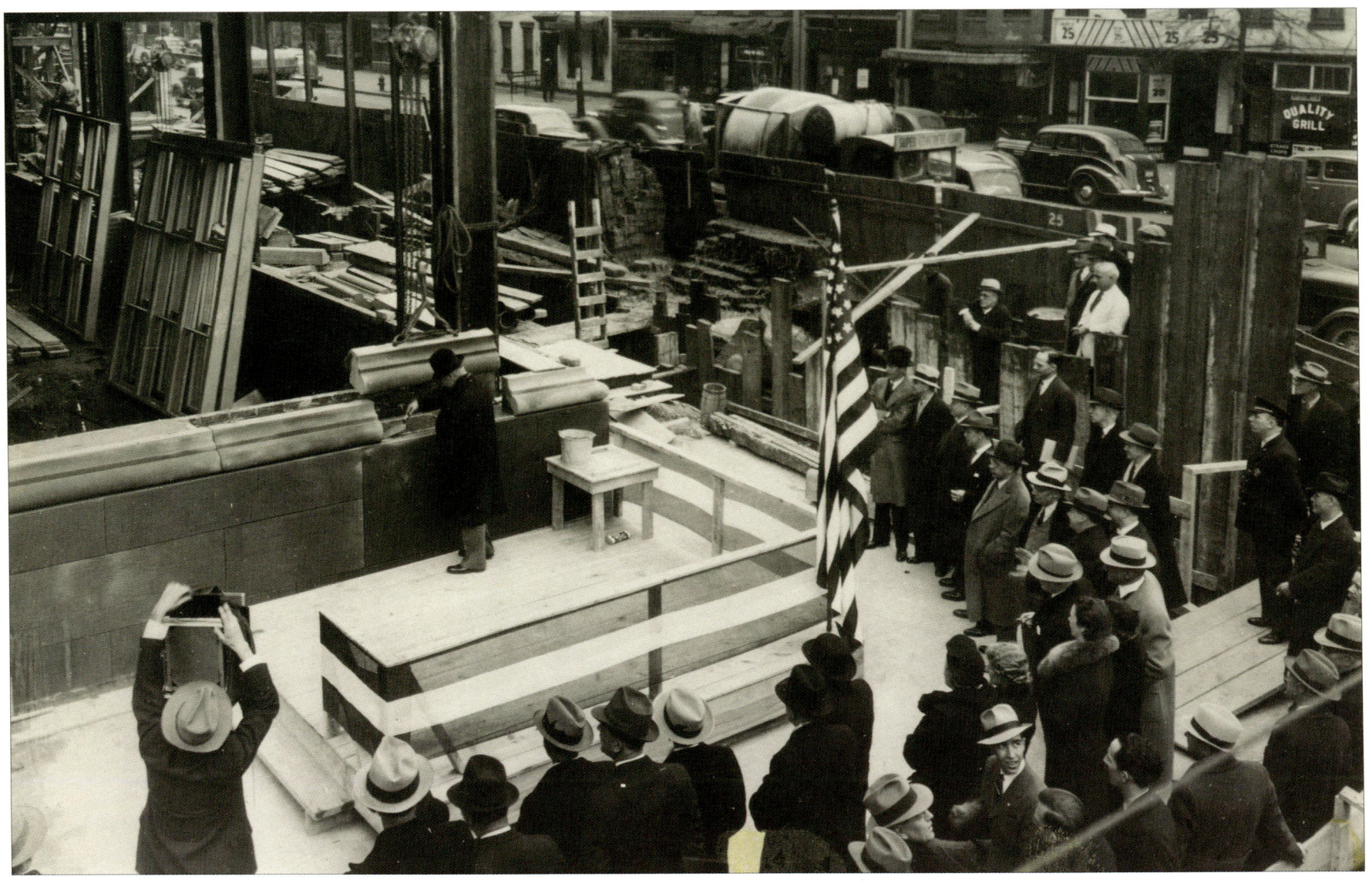

Public Printer Giegengack laid the cornerstone of Building 3, the new main building at the corner of North Capitol and H Streets, NW, on February 21, 1939.

Excavation of the basement of Building 3. The row houses on H Street NW stretch across the upper part of the photo.

An architect's proposal for Building 3, which closely mimics the Romanesque style of Building 1 on the North Capitol Street side, with a rather stern Art Deco façade on H Street.

UNITED STATES GOVERNMENT PRINTING OFFICE BUILDING NUMBER 3 WASHINGTON D C

The final design removed much of the Italianate detail and, while matching the mass of Building 1, presented a more stripped down, modern appearance.

When completed in 1940 Buildings 3 and 4 brought GPO's total floor space to over 33 acres.

Building 1 reflected in the glass of its new neighbor across G Street NW in 2016.

CHAPTER 2

Printing
It Was Our Middle Name

For most of GPO's first 15 decades printing was front and center. GPO was the offspring of the Industrial Revolution, which moved printing with moveable type from a large-scale handcraft to a fully industrial manufacturing process. From its first day GPO was a power shop, no wood or iron hand presses here, but a battery of large bed-and-platen presses, run by an elaborate system of belts and pulleys driven by a 40-horsepower steam engine. Electricity superseded steam power in the 1880s. In its first three decades GPO grew from 23 presses to more than 100, a number which would double in the next 30 years.

At the turn of the 20th century, typesetting, which had previously been entirely done by hand, was revolutionized by the invention of machines that cast metal type on demand. The new process not only saved time in the assembling of words, lines and pages, but eliminated the laborious task of "distributing" type (returning it to cases for re-use). The adoption of machine typesetting (at roughly the same moment when cheaper wood-pulp based paper became widely available) began a revolution, making printed books, pamphlets, and magazines more widely available than ever before.

In the early 20th century technological innovation again shifted from a process in which letters in raised relief (type) transferred ink directly to paper, to a process in which impressions are transferred, on the basis of chemical properties, first to a rubber roller and then to paper. Offset lithography opened the way for longer runs, the introduction of multi-color printing, and eventually today's digital printing.

Although GPO was not always the first to adapt these huge technological shifts, owing to its tremendous size and the huge investments at any given moment in existing technology and skills, once these shifts took place the "Big Shop" grew and diversified accordingly.

For this book, all the allied processes of printing, including composing, platemaking, proofreading, presswork, and photoengraving, are grouped in a single chapter. The images tell the story of more than 150 years of almost uninterrupted technological transformation.

The building opened in 1903 (Building 1) was designed entirely with hand composing in mind. Although by the time of this photo, around 1910, machine composition had made its appearance and was rapidly gaining ground, a significant amount of type was still set by hundreds of hand compositors using a stock hundreds of tons of foundry type.

In 1904, the two most successful systems for setting type by machine were introduced to GPO: Monotype and Linotype. Monotype, which cast individual characters in metal, arrived with 28 machines "on trial." This photo shows 10 of the first Monotype operators, journeymen originally trained as hand compositors.

Monotype battery, circa 1930. Machine typesetting was an immediate success at GPO. From the original 28 Monotypes in 1904, the battery rapidly grew to over 100 by 1920. In 1916, the Lanston Monotype Company was boasting "the largest battery in the world" in its print ads. At that time two-thirds of all the type set at GPO was Monotype.

Monotype was a two-step system, as shown in this photo from the 1930s and the following. These operators typed copy on the keyboard which punched holes on a grid into a 4 $1/2$" inch wide paper ribbbon. Their typing included letters, punctuation, and spacing, all of which was translated into the coded punches on the ribbon.

That ribbon was then read, employing compressed air much like a player piano roll, by the casting machine which interpreted the punches to guide a mold or "matrix" into position for metal to be injected to form individual letters of type, or "sorts." Photo circa 1940.

Casters could be set up for composition (producing galleys of sorts, properly spaced) or for sorts (producing letters, punctuation, etc.) that could be inserted by hand to correct mistakes in galleys). Photo circa 1930.

The GPO Monotype section was remarkable in many ways, starting with its sheer size, 120 keyboards at the peak. The keyboards required no electricity, only compressed air to operate. Because Linotype operators sat next to a pot of molten type metal, the machine was thought "unsuitable" for women to operate. The Monotype section, on the other hand, had female keyboard operators. Keyboard operators were considered journeymen printers. Operators of the casting machines were not. Photo circa 1910.

The two typesetting machines, Linotype and Monotype, made GPO's status as "biggest of the big" possible. The combination of fast and efficient presses, hot metal typesetting, and a seemingly unquenchable demand for printed documents came together at the beginning of the 20th century and made GPO's reputation. Photo circa 1950.

GPO purchased around 20 Linotype machines in 1904 and, after some dispute with the manufacturer, continued to buy the machines steadily through much of the 20th century. Photo circa 1920.

The Linotype, which produced a full line at a time (a "line o type" or slug) was well suited to so-called "straight work" — large unbroken blocks or columns of text. The *Congressional Record*, *Federal Register*, and U.S. patents were all big-volume Linotype products. Photo circa 1910.

Hand compositors feared that machines would replace skilled workers. In fact, because of the vast increase in production made possible by the machines and the burgeoning demand for printed documents, GPO soon employed more compositors than ever before. This photo, from around 1910, shows GPO when this transformation to a fully industrial shop was underway. In the frame are younger men who may well have been trained specifically as Linotype operators alongside older compositors who had certainly been retrained as the machine composition sections grew. With industrialization came increased attention to safety and sanitary conditions and workers were constantly reminded to keep the shop floor neat and use the cuspidors (upper right).

By the 1920s and '30s, when this photo was taken, there were 100 or more Linotypes at GPO. Each machine weighed over 2400 lbs.

The operator keyed copy on the keyboard that had letters arranged according to frequency of use in the English language. Depressing the keys caused a brass key, a "matrix" to fall from a channel in the sloped magazine above into a row just in front of the keyboard. When a complete line had been keyed, the machine moved the line of matrices into position to correctly justify the line and create a mold for the typemetal to be injected into, creating the slug, a complete line of type. All this took less than a minute. Photo circa 1975.

By the 1960s, although offset printing and phototypesetting had made inroads, hot metal was still king. GPO's battery was a mix of machines made by the Mergenthaler Linotype Company and the Harris Intertype Company. The four machines at the right of this 1970s photo are Intertypes, favored by some operators for their easier loading system for magazines of matrices.

One of GPO's many Linotype and Intertype machines was the "General Pershing," a 1910 model 5 machine, first sold to a newspaper in Chaumont, France. After the U.S. arrival in World War I, the machine was requisitioned by the American Expeditionary Forces under Gen John J. Pershing. It became part of the 29th Engineers Mobile Printing Battalion, which printed Pershing's orders and other materials for the American forces from a group of trucks.

One of the battalion's trucks held the "General Pershing" Linotype.

In France, and after the machine was returned to the GPO, "General Pershing" was operated by Cpl. James M. (Jimmie) Kreiter. Here the machine is in use in a fixed location, Camp Babcock, prior to being mobilized in the truck.

After the war, Kreiter remained at the GPO for the rest of his career.

"General Pershing" served in GPO's Apprentice School until the 1950s.

The Pershing Linotype was retired from service in 1950 and was placed in Harding Hall as a memorial to GPO's World War I veterans. In 2011 it became a prominent part of GPO's 150th Anniversary History Exhibit.

"General Pershing's" arrival at GPO in 1920 was not the end of its traveling days. In September 1936, the American Legion held its national convention in Cleveland, Ohio. It featured a parade that was watched by 500,000 people and lasted over 11 hours. One of the units in the parade was a White Motor Company truck with the "General Pershing" mounted on its bed, and Jimmie Kreiter at its keyboard.

The GPO unit was preceded in the parade by an automobile carrying Public Printer A. E. Giegengack, himself a World War I veteran and active Legionnaire.

61

Once type was set, either by hand or machine, a copy (a "proof") was printed from the tray that held the type (the "galley"), on a so-called proof press. This proof was then compared against the original manuscript for accuracy. Photo circa 1930.

Type being assembled into galleys, about 1910. When complete, galleys were bound tightly with string.

The Proofreading Section, or Proof Room, about 1908. Among the earliest photos we have of GPO,

The Proof Room earned the nickname "The Brainery." Copy was read for accuracy, but also for grammar, spelling, and style. This wider view from between 1905 and 1910 clearly shows the emphasis on good light (natural and electric) and the GPO practice of proofreading with pairs of readers.

A pair of proofreaders at work in the 1940s. One reader had the manuscript copy, one had the proof, on which corrections and instructions for the final appearance of the printed page would be marked.

The overall appearance of the Proof Room changed relatively little over most of GPO's history. This view is from the early 1950s. From this location in Building 1, proofreaders could see the Capitol Dome, and be aware when the light in the lantern went out, signalling that Congress was adjourned and the wave of night's work was on its way.

Compositors correcting galleys, probably Monotype. Once the proof was read and marked up, errors would be corrected by pulling the incorrect letters ("sorts") from the galley and inserting the correct ones. For Linotype, the entire line had to be recast. Photo circa 1950.

Compositors correcting Linotype galleys. Corrected lines were cast and substituted for flawed ones. Photo circa 1930.

Once corrected, the galley type was made up into page form, a process known as "imposing." Here compositors are at work at stone-topped tables imposing page forms in frames called "chases." Chases could be taken directly to the bed of the press, although in most cases at GPO, a series of plates, which exactly duplicated the set and imposed type, were struck. A further set of "page proofs" was often taken and checked before plates were struck. Photo circa 1930.

Plates being imposed for the press.
Photo circa 1930.

Once plates were struck, the imposed pages were often "pied" — broken up for the typemetal to be reused. If the order was for a particularly large run, or additional quantities were likely, the type was left standing and stored in anticipation of making further plates and pressruns. Photo circa 1930.

When GPO was created in 1861, the Industrial Revolution had brought a wide variety of innovations and improvements to printing presses. Over its history, GPO has employed a staggering variety of presses, first powered by steam, then by electricity. Presses are classified by the way paper is fed (either by the sheet or from a roll or web), and by the mechanism by which the type and paper come into contact (on a flat bed, a cylinder, a roller, etc.) In a very early photo, web-fed rotary presses are in use in the old (pre-1903) GPO building, probably about 1900.

Close-up of the same web press in the old building, about 1900.

In another photo from about 1905, pressmen are working a Hoe web-fed cylinder press which was bought off the exposition floor at the St. Louis International Exposition in 1904. The press became know as Press #1, because it was the first to be assigned a brass plate with an equipment inventory number, a practice that probably started when Building 1 was occupied. The press eventually became a mainstay of postal card production, and remained in service until the 1980s, when it was donated to a museum.

As GPO grew in the early 20th century, the diversity of work, thus the diversity of presses, grew steadily. In this 1920s view, at least three types of press are visible — web cylinder presses in the foreground, sheet-fed cylinder presses, and the sheet-fed presses known as "bobtails" in the distance.

Rarely did GPO purchase just one of any press. These are sheet-fed cylinder presses. Photo circa 1930.

As machines grew in complexity and capability, they grew in size as well. These are Web-fed presses, probably about 1920.

These presses printed money orders for the Post Office Department in Building 4, about 1950.

Some of the web-fed presses in GPO's Main Pressroom in the 1930s. Many of these machines were as large as a Washington studio apartment.

The center of attention in the Pressroom from 1873 onward were the generations of presses primarily occupied with printing the *Congressional Record*. These presses were used in the 1930s…

... and these were the next generation (still letterpresses) in the 1950s.

The capabilities of presses extended well beyond simply putting ink on paper. Presses could fold, emboss, score, or cut, and sometimes do simple stitched binding. This photo from the 1960s shows issues of either the *Congressional Record* or *Federal Register* coming off the press bundled, wrapped, and ready for mailing.

A mind-boggling amount of work passed through the GPO pressrooms every week. Schedulers in the plant had to arrange jobs for the presses that would do the work most efficiently, and ensure that work was moving through the plant smoothly. These giant tote boards were used to track what work was queued up for what press at any given moment. Photo circa 1940.

In the early years of the 20th century the next huge technological breakthrough after machine typesetting was offset printing, in which an impression of the imposed page was transferred to a photosensitive plate, which then transferred ink to a rubber blanket from which the paper was printed. It was a process that speeded up production and extended pressruns, but because of the vast size of GPO's plant investment, and skepticism on the part of printers about the quality of the product, it only made inroads during and after World War II. Here offset plates are being prepared, during the 1950s.

Offset was a photographic process. The page forms were prepared from photographic negatives, which were assembled by special compositors called Negative Strippers, seen at work here in the 1950s.

Offset plates being developed during the early 1960s. The apprentice in the foreground, Robert Schwenk, would later become GPO Production Manager.

Offset technology opened the way for later developments in electronic typesetting, as machines that cast type were gradually replaced by machines that produced various kinds of photographic output. The machine in this photo from the 1950s composed very primitive photographic type from punched tape.

GPO's first large-scale venture in photocomposition was a system developed jointly by GPO, the Mergenthaler Company, and CBS Laboratories. Dubbed "Linotron" it composed pages from magnetic tape input at a rate that took the hot metal measure of "lines per minute" the next step, to "pages per minute." It was introduced in 1967.

By the 1980s, hot metal typesetting at GPO was on its way out. Linotype and Monotype compositors were retrained, and the shift to offset continued. In 1979, the *Congressional Record* began to be printed from offset plates derived from Linotype forms. On January 6, 1982, the last issue printed from Linotype composition was sent to press. Hot metal production ended completely in 1985. These compositors are correcting the last pages of the *Record* set in hot metal.

Since the introduction of Linotron in 1967, GPO has seen many generations of computer composition systems, in most cases either developed or greatly expanded by in-house programmers. This is the Video Keyboard Section in the 1980s (a descendant of the Monotype Keyboard Section of 60 years earlier).

Publishing agencies or GPO planners might decide that the composed pages should be retained in the Plate Vault, in case additional copies were required. Here galleys are stored in special steel racks. Photo circa 1920.

In this photo from the 1930s, composed plates are logged before being stored in the Plate Vault.

CHAPTER 3

Binding

Bringing it all together

GPO's book binding division, one of the largest and most varied of its kind in the world, is an essential adjunct to the printing operation. Without some means of preserving the correct order of pages, printing loses a primary element of its importance — the ability to transmit complex ideas in a fixed, repeatable form. GPO's Bindery has brought together many millions of printed sheets into useful, and often beautiful, units.

A large percentage of GPO's original 350 employees were Bindery workers, and throughout its history, GPO's bindery has produced a wider variety of products, from folded, single leaf pamphlets to elaborate leather-bound volumes, than any other commercial binding concern. Virtually every type and style of binding in common use has been produced by GPO binders, ranging from work done entirely by hand by skilled craftspeople to highly mechanized processes producing thousands of identical pieces.

Besides producing a multitude of books, pamphlets, folders, binders, and tablets, the Bindery also produces decorative marbled paper for its own use, performs a wide variety of cutting and trimming of paper, and prepares and packs finished products for shipment.

From high quality cloth-covered hardbound books to fine leatherbound volumes, from single section pamphlets to spiral-bound training manuals, and from sewn bindings with paper covers to ruled paper and record books, the Bindery is one of GPO's most distinctive and multi-talented divisions.

In a very early photo, circa 1905, women in the Bindery are folding and collating sections or signatures in preparation for sewing, fowarding, and finishing. Women were a significant proportion of the Bindery workforce from GPO's earliest days.

Bookbinders at work finishing cloth- or leather-bound books, circa 1905. Finishing involves stamping titles, other lettering, or decorative work on spines and covers.

Bookbinders casing-in and finishing hardbound books, circa 1910.

Although a great deal of sewing in the Bindery was done by machine by the early 20th century, much of it was still sewn by hand as well. In this photo circa 1930, bindery women (which was a job title) in the foreground work at hand sewing frames, joining signatures (gatherings of pages) together with linen thread. Workers further back appear to be folding and collating pages.

In this photo from the 1930s, bookbinders in the Library Binding Section are taking sewn blocks of pages through the series of steps known as forwarding, in which the block is secured between cloth or leather covers and made ready to be stamped with titles and decorative rules or devices. The number of skilled workers here is impressive — there are 50 or more visible in this one section of the Bindery alone.

Daniel McConnel Smyth invented a machine for sewing book blocks for high-quality bindings in 1879. GPO adopted the machines almost immediately and ran an extremely large battery, as seen in this photo from the 1930s. Smyth sewing is still used today.

Bookbinding grew steadily more automated in the 20th century. In this photo from the 1930s, machines are used for making cloth-bound cases which are then secured to rounded and backed book blocks (shown here stacked in the foreground).

Machines that fabricate a cloth-covered board case came into wide use around the turn of the 20th century. Here four bookbinders operate casemaking machines in the 1940s.

Bookbinders rounding and backing sewn bookblocks during the 1930s with machines that shaped the spine and applied adhesive for backing material.

Bookbinders use stamping tools to apply gold lettering and decoration to spines and covers, the step known as finishing, in this photo from the 1930s.

A machine that applies the lettering and decoration to made-up cases, circa 1930. The covers may be for *United States Statutes at Large*.

The Bindery has been home to many interesting machines. These women are "indexing" in this photo circa 1910, which in binding terms means cutting the notches known as thumb indexes into the book's fore edge.

Books being taken off a perfect binder, a production line that produced a paperback book with a glued spine. Perfect bindings were invented in the 1920s and GPO was producing many thousands of the inexpensive books and pamphlets per year by the time of this photo in the 1940s.

In this photo from the 1930s, newly cased-in books are packed between brass-edged boards in a hydraulic press that assures that the book will remain unwarped.

A bookbinder operates a machine for cutting rounded corners in this photo from the 1940s. The machine at left is a drill for pages to be inserted in ring binders.

Among the many types of bindings GPO produced was a single section of folded sheets, secured into a pamphlet with a wire "stitch" (similar to a staple). Here, workers are shown on a pamphlet binding line in the 1930s.

GPO's binders produced every kind of folded, stitched, sewn, or glued pamphlet and book. This production line made so-called "perfect bound" books and pamphlets, inexpensive bindings with a glued spine introduced to GPO around the time of this photo in the early 1930s.

Single section pamphlets, being carried along the rail, receive a wire stitch to secure them. This photo from the 1930s is one of many showing employees of different races working side by side. In this period areas in GPO outside the production floor were, like most Federal agencies, segregated.

Bookbinders during the 1940s securing prepared text blocks in cloth-covered cases, or "casing-in."

Workers in the Bindery collated, folded, and sorted all manner of products. Here, training poster sets are collated during World War II.

Printed sheets and blank paper often had to be cut to size. These enormous hydraulic cutting machines sliced through thick stacks of paper as though it were bread in this photo from the 1930s.

Machines for folding large quantities of paper were invented in the mid-19th century. Here, folding machines are being operated in the 1930s.

These large machines fold large sheets of paper down to size during the 1920s. Machine folding was another of the 19th century technologies that greatly expanded GPO's production capacity.

In an era before typewriters or computers, a significant amount of Government record-keeping used bound ledger books and other types of ruled pages. Ruling, done by these machines, circa 1910, was the application of lines using water-based inks. These machines are pen-ruling machines: sheets of paper were fed onto a moving blanket, each held in place by the cords visible in the photo. Pen nibs fed by ink reservoirs were positioned above the paper. After passing under the pens, the paper was carried onto another blanket underneath the machine to dry, before being delivered to a pile at the end. Ruled pads and record books, as well as writing paper, were significant GPO products well into the 20th century.

Ruling machines applied pale blue and red lines to sheets of paper for use in lined tablets and record books in this photo from the 1920s.

A large bank of ruling machines, circa 1920.

A GPO bookbinder in this photo from the 1960s, demonstrates edge marbling, where a decorative pattern is applied to the edges of a bound book by touching it to colored pigments suspended in a gelatinous medium. GPO has produced its own marbling since World War I, and continues the craft today.

The Bindery was responsible for packing finished products for delivery. In this photo from the 1930s, bindery workers bundle and wrap publications in kraft paper.

Folded and wrapped publications (perhaps the *Congressional Record* as shown here), were packed into canvas mail bags, which were then carried on a conveyor system through tunnels under North Capitol Street to the main Post Office at the corner of Massachusetts Avenue for mail delivery. Photo circa 1930.

Over the years, GPO operated branch printing facilities in several Government agencies around Washington. One of the largest was at the Library of Congress, which had not only a print shop that produced the Library's millions of 3" x 5" catalog cards, but a comprehensive bindery which handled periodical binding, repair, and conservation of the Library's collections. Photo circa 1930.

CHAPTER 4

Support and Administration
Behind the Scenes

Keeping a vast industrial shop like GPO humming around the clock throughout its history has required a supporting staff as large and diverse as the skilled force who composed, printed, and bound the documents themselves. From machinists to carpenters to chemists to stock keepers, GPO's support units provided the infrastructure that made possible the production of high quality printed and bound documents with speed and efficiency.

Employees in the Engineering divisions kept machinery repaired, often made necessary parts, maintained and improved the buildings, and provided light, heat, and motive power. The Stores Division tallied and moved the vast stock of raw materials like paper and binding materials throughout GPO's plant. GPO carpenters and cabinetmakers produced specialized furniture and fixtures. GPO was for much of its history almost entirely self-sufficient.

Beginning in the early 20th century, the Tests and Technical Controls Division maintained the quality of type metal, tested the vast stocks of paper for conformity to published standards, made ink, press rollers, and adhesives, and performed research to find new and better methods and materials to improve GPO's economy and efficiency. The Testing Division staff were nationally known experts in paper analysis, metallurgy, printing processes, inks, and adhesives.

With the growth of GPO after 1900, a program of apprentice training was started in the 1920s that provided trained journeypersons for the printing and binding ranks, as well as the skilled support areas. This chapter includes photos of apprentices at work throughout the plant. The apprentice school grew to be a "university of printing and binding," turning out generations of GPO printers, proofreaders, bookbinders, platemakers, compositors, and other skilled craftspeople.

In addition to operations that directly supported production, a host of clerks, typists, librarians, estimators, bookkeepers, accountants, designers, police officers, messengers, drivers, and administrative assistants contributed to making the Big Shop run.

Vast stocks of the raw materials of printing — paper, ink, type metal — had to be on hand at all times. Here workers in the Stores Division stack spools of paper for web presses in the late 1930s, prior to the construction of the new warehouse, Building 4, opened in 1938. This area was probably within the warren of old buildings that surrounded the original Wendell structure, which were demolished to make way for Building 3 in 1938.

Before the construction of Building 4 in 1938, supplies of materials were stored across GPO's complex. In this photo from the 1930s, an electric tractor pulls a train of 10 trailers, probably loaded with paper.

In the days of GPO's greatest output, every nook and cranny was utillized. Here paper is stored in the basement of Building 1 during the 1930s. Two of the massive pylons that support the building are visible at left.

Various kinds of trucks, tractors, cranes, and lifters were used to move and stack heavy materials around GPO's plant. These electric tractors were used for moving paper and product during the 1920s.

At any given moment GPO sought to have more than a month's supply of paper on hand in its storage areas. One challenge of working with paper is its great weight. Here heavy spools are mounted on mechanized racks to ease the transfer onto the feeders of web presses during the 1910s.

One of the most striking aspects of many of GPO's historic photographs is the intense amount of organization they reveal, along with the emphasis on cleanliness and tidiness. This view of the General Stores Division from the 1930s illustrates the massive amount of organization required to keep spare parts and supplies readily at hand. It also shows the extent to which early 20th century theories about workplace efficiency held sway: for example, having a step stool at the end of each range of shelving would produce a quantifiable saving of steps that translated to increased efficiency. It is worth noting how fastidiously clean everything appears. In printing, a lack of attention to cleanliness leads to spoilage and waste of materials and time. The attention to cleanliness extended across the organization.

Recordkeeping and accounting for materials was a massive clerical task. The clerks at the center in this photo from the 1930s are using a "Kardex" file, a system for "visible indexing" that paved the way conceptually for later machine assisted systems.

As GPO matured into a fully industrialized operation in the early 20th century, a key to its ability to produce vast amounts of work economically was the careful control of materials. The Division of Tests and Technical Controls was created in the 1920s to support efficiency. Paper, type metals, inks, adhesives, and chemicals were tested and improved. Every stage of the manufacture of ink, adhesives, press rollers, and type metal was monitored. Here a chemist analyses ink or solvents during the 1920s.

These analysts are testing paper during the 1940s.

One of GPO's paper experts assesses the chemical properties of paper during the 1960s.

Analysis of metals used for typecasting and platemaking was performed in the Testing Section in this photo from the 1930s.

Among its varied responsibilities, the Testing Division was responsible for the manufacture of printing inks. In this photo from the 1930s, pigment is mixed with solvents piped by gravity to the 5th floor from tanks on the 6th. The machine at right is a mixer.

In addition to making ink, GPO formed its own ink rollers for the presses. These futuristic-looking machines dates from the 1930s.

Among the many materials and supplies that GPO required, the appetite for type metal was voracious. In the 1920s and 1930s more than 5 million pounds of type-metal (an alloy of tin, lead, and antimony) were used annually. Only a fraction of the metal was "new." In these large furnaces, shown in the 1950s, previously cast type was remelted, dross (waste) was removed, and percentages of the three components were restored or "corrected." The molten metal was then poured into the molds…

…from which came "pigs" which were suspended into the pots of Linotype, Monotype, and Ludlow machines. The fans visible in the previous photograph remind us that air conditioning was not introduced until the late 1930s, and before then the heat in the Metal Room on a Washington summer day must have been astonishing. Photo circa 1950.

Printing called for a variety of solvents and lubricants. In this photo from the 1930s, these pumps delivered gasoline, kerosene, and other solvents.

From 1861 until the 1910s, GPO's deliveries to the Capitol, the White House, and other agencies were made by horse-drawn wagon. The original Wendell property in 1861 had a stable, but by the turn of the 20th century the stable had been moved to leased space nearby. In this photo from the 1890s, delivery wagons are lined up at the right and the Public Printer's carriage is at the center.

Automobiles came to GPO in 1912 in the form of Baker Electric trucks, manufactured in Cleveland, Ohio. The chain-driven trucks ran on large, heavy batteries and had more in common with the wagons they replaced than with later automotive design.

This photo from 1915 reveals three generations of Washington transportation: the GPO Baker Electric truck is sitting on top of the tracks of the North Capitol Street streetcar, amid the residue of horse drawn transport.

The fleet of GPO electric trucks in front of the east face of the Capitol, about 1915.

By the 1920s GPO was using Mack diesel-powered trucks, although the Baker Electrics are still visible in the line. The fleet is parked in front of Building 1 and the old building.

GPO's delivery drivers and messengers in a photo from the 1960s. The green GPO trucks and uniforms of the Delivery Section were familiar across the District. The employee at the right, in the black uniform, was the Public Printer's driver, Nelson Washington.

Electricity came to GPO in 1882. These electricians, in photo from about 1910, are at work on a variety of electrical devices.

These switchboards controlled the distribution of electrical power to circuits throughout the buildings. Photo circa 1930.

In this photo from the 1940s, a pneumatic tube system moved messages and copy swiftly between divisions. Documents were placed in the canisters visible at the lower left and whisked through the appropriate tube by pneumatic pressure to their destination. Parts of the system remained in use into the 1990s.

Because of the size and complexity of its operations, and the demanding requirements for quick delivery, GPO developed a culture of "making it here," which stretched from inks and adhesives to furniture and crates. Here carpenters are using special machines for making shipping boxes. Photo circa 1930.

Mimeograph ink, manufactured at GPO, is packaged for shipment to agencies, in this photo from the 1950s.

Production of printed documents inevitably generates paper waste. In this photo from the 1940s, waste paper is forked into a baling machine in preparation for being shipped to a mill to be pulped and (in modern terms) recycled.

Many machine parts and repairs could be economically made by GPO's blacksmiths in the Metal and Pipe Section. In an earlier day, blacksmiths also kept GPO's delivery fleet working, shoeing the horses that pulled delivery wagons. Photo circa 1930.

Public Printer George Carter established a separate department for job planning which made the writing of specifications more systematic and consistent, thus improving service to agencies and improving efficiency and economy in the plant. Photo circa 1930.

In this photo of GPO's Planning Division from the 1960s, GPO jackets — printed envelopes which bring together all information about a particular job order, and which originate with planners — are visible.

GPO installed its first telephones in the 1890s, and the first known telephone directory was a tiny folder measuring 3" x 4". Here operators run GPO's main switchboard in Building 1 during the 1930s.

Type metal ready for recasting went to this loft above the metal furnaces in this photo from the 1970s. After the closeout of hot metal composing, this space became a meeting room, Hasse Hall, named for one of GPO's first librarians.

Like many large printing shops, GPO produced many products that were distributed by mail to individual subscribers, either on Capitol Hill, in Federal agencies, or elsewhere. In this photo taken during the 1930s, machines using Addressograph plates are used for direct-mail addressing.

The Accounts (later Finance) Division used IBM tabulating machines for keeping track of agency accounts. This photo shows operators entering information on punch cards during the 1940s.

These macines read and tallied the punched tabulating cards during the 1940s. Although used throughout the Government and the business world, the first extensive use of tabulating machines was for the U.S. Census. GPO produced the tabulating cards.

Beginning in 1883, GPO employees were assigned a set payday on which they would line up at the paymaster's window to be paid in cash. This photo shows the Paymaster's Office in 1913.

Clerks and messengers in the Public Printer's office, about 1915.

The Personnel Division was located on the first floor of Building 3, in the area now occupied by GPO's 150th Anniversary History Exhibit. This photo is from about 1960. Generations of GPO employees were sworn into Government service in this office.

One of the many responsibilities of GPO apprentices in the 1920s and 1930s was to lead tours of the plant. When Building 4 opened in 1940, this room, immediately adjacent to the main lobby, was designated for greeting visitors and forming tours. Tours were discontinued during World War II, and the room was eventually turned over to the Personnel Division. It returned to being a Visitor's Center under the new security arrangements instituted following the attacks of September 11, 2001.

The first recorded security force at GPO was during the Civil War, when the two companies of the so-called Interior Dept. Regiment, Co. F and Co. G, guarded the buildings at night. By the 1930s, a large guard or watchman force protected the buildings and employees.

The Captain of Watch, 1930s.

In 1970, Congress enacted legislation creating a force of "special policemen" at GPO, with authority to enforce the law, make arrests, and carry firearms to protect GPO property and employees.

Apprentice Program

In 1939, Public Printer A.E. Giegengack commissioned one of GPO's contractor photographers, probably Tenschert, to document the Apprentice School by photographing members of the class of 1940 on the job. Those photos are a remarkable view of GPO: virtually every stage of production is depicted in sharp detail. The photos themselves are some of the most artistic photography in the entire collection. This book is the first time all the photos from this series have been published together.

These photos are remarkable for what they explicitly depict, but also display rather starkly other realities of the workplace of that time: only two women graduated in the class of 1940, and no African Americans appear. Although the apprenticeship was not barred to women or minorities at the time, it is clear that their participation was far below what we expect today.

171

Apprentice life began with classroom instruction. Apprentices were taught not only about the basics of printing and binding but English grammar and usage. Here students are drilled on sentence diagramming.

Apprentices learn hand composing. At left is one of the women who entered the class of 1940, but who did not finish, Beulah Farrell.

At this period hot metal typesetting was at its peak. Apprentices learned both Linotype . . .

. . . and Monotype operation. This photo is of one of the women in the Class of 1940, Blanche Boisvert. Women were trained on the Monotype keyboards, but not Linotype.

Apprentices were given a thorough grounding in absolutely all aspects of the printing and binding trades. Here an apprentice is studying the formation of letters, part of instruction in typography

Although GPO did not cast its own foundry type, apprentices learned the process to gain an understanding of all branches of the printing trades. This apprentice is pouring molten type metal into a casting box which contains a type matrix or mold.

Apprentices learn proofreading, working in the standard GPO practice of the time: teams of two readers, one with manuscript, the other with proof copy.

In the 1930s GPO was still primarily a letterpress shop, but a variety of platemaking techniques were employed for various classes of work. Here an apprentice adjusts a chase of type for height before taking an impression for the casting of an electrotype plate

Apprentices inspect a plate which has been immersed in the etching tank.

Electrotype plates are imposed into page forms.

Electrotype plates are imposed into page forms.

At the time of these photos in the late 1930s, photoengraving was a relatively recent addition to GPO's capabilities. Apprentices work with a large format camera to photograph artwork.

An apprentice guides a router over a photoengraved plate.

These apprentice pressmen are checking color match and density of printing ink in the apprentice job press room.

Apprentices eventually were cleared to operate all types of presses, like these platen presses in the job shop.

Many of GPO's internal jobs, including cafeteria menus, announcement sheets, and programs for events, were printed in the apprentice job room.

The apprentice job press room.

Feeding paper on a flatbed cylinder press.

Press check on one of the offset presses.

Apprentices were also trained as bookbinders. Here an apprentice operates a Cleveland folding machine.

An apprentice works at rounding and backing a sewn and glued bookblock, prior to its being secured in hardback covers.

GPO began marbling paper as a wartime expedient during World War I and has continued to this day. Here a bindery apprentice marbles the edge of a large volume.

Apprentices at work finishing fine leather bindings.

An apprentice stamps gold leaf lettering on the spine of a leatherbound book.

GPO produced a wide variety of lined and ruled paper and record books, as well as lined and ruled forms. Here an apprentice adjusts the pens of a ruling machine which applied the pale red and blue lines.

This group photo from the 1920s gives an idea of the number of apprentices in the program after Public Printer Carter's expansions.

CHAPTER 5

Superintendent of Documents
Public documents, our specialty.

The major reform of the public printing statutes known as the Printing Act of 1895 brought a wide variety of changes to GPO. With this single statute GPO was transformed from a printing and binding concern to the central point in the U.S. Government for dissemination of Government publications. The 1895 Act set the stage for GPO's subsequent role as a multi-faceted hub of Government publishing activity.

Distribution of publications to designated libraries had been the responsibility of a Superintendent of Public Documents in the Department of the Interior. The 1895 act brought that responsibility, and the title Superintendent of Documents, to GPO.

GPO's first action was to establish its own library of Government publications, which served as a point of reference across the rest of the Government and the Nation until its discontinuation in the 1970s.

Since the 1895 Act, GPO has worked with congressionally-designated depository libraries across the country to provide no-fee access to Government publications distributed by GPO. That cooperation has grown over the years to encompass libraries of every type and size, from small public libraries in rural areas to large research libraries at internationally known universities. All have in common a commitment to providing Government information freely to all.

GPO has also operated bookstores and mail-order programs to make publications broadly available for sale, and in 2000 opened its online bookstore.

With GPO's entry to the digital age its digital dissemination activities have been under the purview of the Superintendent of Documents. In 1993, GPO was directed by Congress to begin online dissemination and created *GPO Access*, which made thousands of Congressional and agency documents available over the World Wide Web. GPO's third generation of search and access, **govinfo.gov**, continues that work with a wider variety of information products available, and a growing community of users.

GPO's technological transformations, paired with its ongoing commitment to no-fee public access, significantly widened the Government's ability to communicate with its constituents, and made GPO the central point for **Keeping America Informed**.

The first GPO Superintendent of Documents, Francis Asbury Crandall, was a Buffalo newspaper editor. He seems to have been very aware of the progress in the emerging field of librarianship, and made his first major initiative as Superintendent the establishment of a library of public documents. The library was built, at first, with the accumulation of documents in agency store rooms and attics all over Washington, which were to be turned over to GPO under the Printing Act. Crandall stepped down as Superintendent in 1897, but remained as an employee in the library for many years thereafter.

The first librarian Superintendent of Documents Crandall hired was Adelaide R. Hasse, who came to GPO from the Los Angeles Public Library in 1895. She and a team of helpers collected thousands of accumulated documents from agencies, packing them in burlap bags to be loaded in wagons and brought back to GPO. She devised the outline of a classification scheme that organized the library according to the "Government author" or agency of origin rather than subject. Her classification system was put into use by her successors at GPO, and is still in use today.

GPO's Public Documents Library was at first in rented space in the Union Building, on H St. NW, several blocks from GPO. Around the turn of the 20th century the library was moved to the 8-story annex on the G St. site, where it remained for about 20 years. The two persons in the foreground of this photo from about 1905 are probably members of the library staff.

The library featured two-tiered iron and steel book stacks, which were the state of the art in library design. By 1910, the library held 124,000 volumes, and was adding every public document produced by GPO.

When Building 2 was completed in the 1920s the library occupied new, expanded space on the 7th floor. The two-tier bookstacks were reconfigured and expanded and there was room for a growing staff. The library was not only used as a reference collection for cataloging and answering queries, but was the administrative center of the depository library program. Photo circa 1930.

The library and cataloging staff maintained two card catalogs, one a "dictionary" catalog, arranged alphabetically by author and title, used for locating documents on the shelves of the library, and the other a "shelf list," arranged in classification number order, which was used primarily for the cataloging and classification purposes. The photo from the 1940s has many items familliar to GPO employees through the years: the loose-leaf three-month calendar, wall mounted fans, and round paper weights cast from typemetal.

The 1895 Printing Act brought an already-existing authority for the distribution of documents to libraries from the Interior Department to GPO. Libraries across the country, in all congressional districts, were designated by Congress to receive documents and make them available to the public. Since documents remain Government property, thus they are "on deposit" with libraries, and the libraries themselves became known as depository libraries. About 420 of them were listed in the 1895 annual report of the Superintendent of Documents, and they received more than 150,000 documents. The Dayton (Ohio) Public Library, shown here in 1922, was designated in 1868 and remains a depository library in 2016.

By the 1980s there were nearly 1400 depository libraries, 52 of which were designated "regional depositories" which received all publications and retained them permanently. The remainder were "selective," choosing the types of publications they received, and retaining them for a minimum of five years. The Distribution Branch packed shipments of documents for the libraries and handled claims for missing items.

In 1985 distribution was managed using a new system of "lighted bins." Here Public Printer Ralph Kennickell learns about the system from Joan Monroe. The lighted bins remained in use until 2013.

Almost from the beginning, the Documents Division provided reference services to the public and libraries. One of the original intentions of the Public Documents Library was that it would serve as a "key" or catalog to the large inventory of documents GPO took on by receiving the accumulated stock from agencies. The library grew hourly as new documents were printed. These employees during the 1910s are answering letters from across the country seeking copies of publications from GPO's stock.

Employees answer queries for Congressional documents during the 1930s.

Thousands of documents were kept in stock to be sold at cost to the public. This is the documents shipping section in the original Wendell building complex, in the 1930s. Visible at left are the vertical bins that were devised by GPO for the storage and organization of the documents stock.

Beginning in the 1920s, GPO had a bookstore open to the public. The original location was very inconvenient, and in the 1930s it was moved to Building 2.

GPO's bookstore was remodeled and expanded in the 1950s when it was moved to Building 1, where it has remained ever since.

GPO eventually opened bookstores across the country, Deputy Public Printer Joseph E. Jenifer opened the Portland, Oregon bookstore in 1988, a practice that ended in the 1990s.

Staff in the Superintendent of Documents Sales Division promoted the use and sale of publications. This photo from 1949 is from a promotion highlighting the sale of the millionth copy of the best-seller *Infant Care*.

CHAPTER 6

Life of GPO

"...as wholesome an atmosphere as can be found in any industrial plant in the world".

The first major transformation in GPO's ongoing history was already underway when Congress created the agency in 1861: the craft-based printing shop of Cornelius Wendell was on its way to becoming an industrialized workplace, a printing factory. By 1905, this transformation was complete, and in the first years of the century successive administrations sought to make the large and growing workforce more efficient and more productive.

It was in this era that reformers attacked poor industrial working conditions with remedies that sought to make the lives of workers easier. Medical care, improved sanitation, attention to safety and accidents, and relaxation and recreational opportunities all sought to create workers who were healthier and better able to do good work.

GPO enthusiastically joined this progressive trend with a host of workplace improvements, activities, programs, organizations, and teams that made the Big Shop more like a self-contained city than ever. Beginning with the introduction of a medical department in 1903, and continuing with the building modifications in the 1920s that introduced the cafeteria, Harding Hall, relaxation and recreational space that included a bowling alley, and an employee-managed association that sponsored musical organizations, sports teams, and events like plays, movies, and dances. GPO's life, in the production areas and offices as well as in non-working areas, was closely linked with the lives of its employees.

These progressive era reforms and organizations, augmented over the years, are still in evidence in today's GPO, from the annual cycle of holiday and other special observances, to the Medical Section, to the organizations and teams that still operate, changing and adapting as GPO has transformed itself, again and again, over its 155 years.

When George H. Carter became Public Printer in 1921, he immediately began a program of sweeping Progressive Era workplace improvements that sought to improve employee morale and productivity by making life inside the buildings a bit more pleasant. GPO had never had a place for meals to be eaten, and having food sold, stored, and consumed in the workrooms of the plant caused a variety of difficulties. Carter directed an operating surplus at making the previously cramped and leaky attic story of Building 1 a full 8th floor, and put in it a cafeteria and other amenities that greatly improved the working life of GPO employees. This is the cafeteria seating area, about 1923.

The cafeteria served hundreds of employees daily on all shifts. Lunch and dinner breaks were just 30 minutes, so serving lines and seating areas were bustling. Photo circa 1925.

Everything from a light breakfast to full hot meals were served, with daily specials and a host of desserts. Photo circa 1930.

The cafeteria was operated by an employee-supported association to which all employees automatically belonged, and which many supported with a nominal membership fee. Here Public Printer A.E. Giegengack and some of his executive staff receive their membership cards during the 1930s.

The renovation of Building 1 that created the cafeteria included an impressive kitchen …

... and bakery. Photos circa 1930.

The cafeteria received a streamlined chrome makeover in the late 1950s.

Upper level managers had their own dining room built during the 1929 renovation of the cafeteria and Harding Hall. The Refectory was furnished with matched oak paneling and a stone fireplace, as shown in this photo from the 1930s. It is used today for special events and meetings.

The renovation of Building 1 also created a new assembly room, named for President Warren G. Harding. Harding Hall featured a stage for musical and theatrical performances, a good piano, and space that could be filled with seating, or cleared for dances and other activities. Photo circa 1925.

These views give an idea of its orientation, with the stage in the north east corner and the elevators and stairway beyond. Although remodeling raised the ceiling to make a full story, the hall still had a much lower ceiling than today.

227

The octagonal gazebo could be used as a bandstand for dances or other purposes. Photo circa 1925.

Harding Hall was renovated in 1930. The ceiling was raised again, and a fully rigged stage was added . . .

. . . along with a balcony for additional seating. The hall now seated 1,800. Photo circa 1930.

Harding Hall continued to be the scene of concerts, lectures, films, celebrations, and dances like this one raising funds for war bonds in 1941.

Every December since Harding Hall was dedicated on Christmas Eve, 1921, a Christmas tree and model train layout have brightened the holiday season. This photo is from 1922.

Generations of GPO employees and their families have enjoyed the annual tradition of "tree and trains." Photo circa 1950.

In the 1980s, GPO began to welcome families from the surrounding community for an open house that featured the tree and trains.

One of the most popular of the workplace innovations of Mr. Carter's administration was a duckpin bowling alley. It originally had 4 lanes. Photo circa 1925.

The bowling alley was home to men's and women's leagues on all shifts. Photo circa 1940.

Duckpin bowling, a variation on 10-pin bowling, uses smaller pins and a ball about 5 in in diameter with no finger holes. It was a regional preference in the Baltimore and Washington area. In their first form, the GPO lanes lacked automatic pin setters. Photo circa 1930.

The bowling alley was renovated several times. After World War II two additional lanes were added.

Beside the bowling alleys was the Green Room, a large lounge and meeting space furnished with comfortable furniture. Photo circa 1930.

G.P.O. ORCHESTRA, 1940
LEON BRUSILOFF, CONDUCTOR

AL GUARAGUA, MANAGER-DIRECTOR

The association that operated the cafeteria also served as an umbrella organization for musical groups, clubs, sports teams, and other activities. GPO's orchestra played weekly at lunch and dinner breaks, and at concerts and dances throughout the year.

The description attached to this photo describes it as the audience at a GPO orchestra concert applauding a performance of the popular favorite "The Singing Hills," in 1940.

GPO also boasted choral groups. The two pictured here date from the era of forced segregation. Both the white chorus pictured on this page and the counterpart for African-American employees on the following page were very popular.

242

GPO's African-American chorus, directed by Ethel M. Gray, was in demand for performances all over the District and on the radio. Photo circa 1935.

The GPO Choir lived on long after the era of segregation, and performed for holidays, official events, and observances. In this photo from the 1980s, the GPO choir sings carols in one of the production areas.

Many sports teams have existed over the years. This men's basketball team is from the 1940s.

This baseball team was league champion in the "Colored Departmental League" in 1922, during the era of segregation.

GPO's Boxing Club during the 1940s.

The Women's Rifle Club, during the 1940s.

GPO employees have supported many charitable causes. This booth in Harding Hall encouraged membership in the Red Cross, during the 1920s.

GPO's drive for the March of Dimes, during the 1930s.

This group of African-American women is sewing for the war effort during World War II. President Truman finally ended official segregation in Government offices following the war.

251

After World War I, veterans groups became a very important part of the life of GPO. GPO's American Legion Post had about 450 members in the mid-1930s, and its band played at civic and patriotic occasions all over the District.

The organization for African-American World War I veterans during the era of segregation was the United Veterans of American Wars. The Col. Charles Young Unit is shown here in the 1930s.

GPO has honored its war veterans on the first floor landing in Building 1 ever since a GPO employee, Charles A.R. Jacobs, who was killed at the battle of Ypres in World War I, lay in repose on the landing before his burial at Arlington National Cemetery in 1926. The Veterans Landing has been refurbished and expanded numerous times. Photo circa 1975.

Beginning in 1983, GPO's Veterans Memorial Landing has been the scene of a wreath-laying ceremony each Veterans Day.

GPO has historically been a workplace where employees achieve long records of service. The two longest serving were W. Andrew Smith, longtime Congressional Record clerk, who served 68 years, until his death in 1941…

... and Virginia F. Saunders, who served as Congressional Documents Specialist until her death in 2009 following 63 years of service.

GPO first created a medical office in 1903 and eventually operated a complete Medical Section that dealt with emergencies, screening, occupational health issues, vaccinations, and routine health concerns. This photo is from the 1910s.

The Medical Section was considered comprehensive and advanced in the 1920s.

The Medical Section, shown here in the 1960s, was equipped for treating emergencies ...

... and offered health screenings, such as this one for glaucoma.

An employee has a chest x-ray.
Photo circa 1950.

Hand in hand with the Medical Section, GPO's concern for a safe and sanitary workplace has a long history. This poster from the early 20th century reminded employees of this concern.

In an era when many printers chewed tobacco, the cuspidor was an essential tool in maintaining a sanitary workplace. This machine washed the hundreds of cuspidors that were distributed around the building daily. Photo circa 1935.

Much of GPO's history saw a very large workforce, working around the clock, producing printed documents on very tight schedules. A system of clocks and bells alerted employees to the start and end of shifts and breaks, and various systems of chimes and bells conveyed other types of messages. This console in Building 1 controlled the various bell systems in the 1940s. The bells remained in use until the 1980s.

Buildings 1 and 3 in 2016.

A Note on the Photographs

All the photographs in this book, unless otherwise credited, are from GPO's collection. A selection of GPO's digitized historical photographs is available online at **www.gpo.gov/about/gpohistory/**.

Colophon

The text for *Picturing the Big Shop* is set in Helvetica Neue, a digital version of the neo-grotesque sans serif typeface designed in 1957 by Max Miedinger for the Haas Type Foundry in Switzerland. GPO began to use sans serif grotesque (or gothic) typefaces for hot metal composition in the 1940s. Helvetica seems to have joined the GPO type catalog with the introduction of Linotron and large-scale phototypesetting in 1967.

It is printed using vegetable-oil based inks on coated offset book paper containing 10% postconsumer recycled fiber, utilizing a chlorine-free process for enhanced permanence. The cover is printed on uncoated cover stock containing 30% postconsumer recycled fiber. Both papers carry nationally and internationally recognized chain-of-custody certifications.